WORKING WHILE BLACK

A WOMAN'S GUIDE TO
STOP BEING THE BEST KEPT SECRET

Written By
Dr. Tana M. Session

Foreword By: Dr. Lois Frankel
Featuring an Interview with
Swati Mandela

"The Black woman is the most unprotected, unloved
woman on earth...
she is the only flower on earth that grows unwatered."
~ *Kola Boof*
Novelist

FOREWORD

By Dr. Lois P. Frankel
***New York Times* Bestselling Author of**
Nice Girls Don't Get the Corner Office

Early in my career as an executive coach, I was often asked to help women prepare for leadership roles. Enlightened companies wanted to level the playing field – or at least they said that they wanted to. It quickly became abundantly clear that the playing field was not going to be leveled anytime soon. You see, the world of work is like any competitive sport—it's a playing field, and there are rules, boundaries and strategies. If you break the rules or go out of bounds, there's a penalty. Successful people figure this out and create a strategy for winning the game.

There's a problem with this, however. The rules are different for men and women, for older workers and younger workers, for long-tenured employees and new employees— and for Caucasians and people of color. The rules are less stringent, and the playing field is wider for Caucasian men. This factor translates into the opportunity to make mistakes or go out of bounds and not be penalized. White women, men of color, and women of color find the rules and boundaries of

those same corporate playing fields more narrowly defined. This factor results in an increased likelihood that they will go out of bounds and suffer the consequences; Black women having the narrowest rules and fields of all. Is it fair? Of course not. Is it true? Well, if you're reading this book, you *know* it is.

Let me give you just one example. I was called into a major automobile manufacturer to coach a Black female head counsel. Her boss told me she was difficult to work with, had a sharp edge to her, and people avoided her. My first thought was, don't most corporate attorneys fit that profile? When I met her, I didn't find her warm and fuzzy, but neither did I find her abrasive, cold or aloof. I found her self-confident and intelligent; in other words, she had a brain and something valuable to say. I decided to get 360-degree feedback on her performance to understand how her peers, direct reports and management saw her.

The feedback was illuminating. Her direct reports and her peers had no problem whatsoever with her. She was described as intelligent, helpful, a team player, willing to make tough calls and a pleasure to work with. This was definitely a disconnect with her management's feedback, who said she was difficult, angry, stubborn, unyielding and abrasive. As I probed more deeply, it became apparent that the woman was not supported by *her* manager, who reported to the division president who wanted to do things his way—whether his way was legal or not. So, in the process of doing the job for which she was paid, she became the scapegoat. Her only goal was to

protect the company from liability, but her management saw it as being an obstructionist.

As I told the woman, I can teach you how to play on this field, but you're going to have to change your behaviors—behaviors that I personally see nothing wrong with. The fact that your peers and direct reports respect you tells me you're doing a lot right. However, if you want to keep your job, you're going to have to manage differently. Had she been a Caucasian man (or perhaps even a Caucasian woman), I don't think she would have been as threatening to management. My assessment (which I shared with her) was that she should start looking for a playing field that better suited her, one where her strengths would be a welcomed asset and not a liability. Her choice was to stay and try to have management see that she had a lot to offer. Even though I underscored my perceptions with her boss, she was eventually terminated. The narrowly defined rules and playing field couldn't tolerate a Black woman of this magnitude.

Since that time, I have searched without success for books (or even one book) that I could recommend to Black women that would clearly illuminate the ways in which the deck is sometimes stacked against them and how to maneuver successfully on the playing field called work. It's a challenge for *all* women to play by the rules yet still be authentic in the workplace—and even more so for Black women. But the Black women who asked me about writing a book didn't really want to write one for their sisters. They didn't want to be pigeonholed

as an advocate for Black women, in some cases because they thought there wasn't enough money in it or that it would limit opportunities, and in other cases, because they wanted to be seen as more mainstream. That's why I was thrilled when Tana first approached me about her idea for *Working While Black*. She has the courage to speak truth to power—the sign of a true change agent.

As you will soon learn, Tana's life hasn't been easy. Her career path wasn't linear. Yet, she refused to allow *anyone* to define her. She is superb at laying out the problem based on her own challenges as a Black woman and a Human Resources professional. But this book doesn't stop there – a teacher, educator and motivator at heart, Tana, provides solid solutions for how you can *Stop Being the Best Kept Secret®*. Not only is her own story inspirational, but her interviews with other inspirational Black women sheds light on how you can achieve your professional dreams. Everything you need to know to create a plan for making tomorrow better than today is contained within these pages. The question is, do you have the courage to re-write your script? In the words of businesswoman and self-made millionaire, Madam C. J. Walker: "Don't sit down and wait for the opportunities to come. Get up and make them."

INTRODUCTION

Everyone may not know Yasmine James, so allow me to introduce (or reintroduce) her to you. Yasmine is the 20-year-old woman who was viciously attacked while working the front counter at a McDonald's located in St. Petersburg, Florida, in early 2019 by a 40-year-old White male customer. During the attack, Yasmine had to physically defend herself while male coworkers, including her manager and other bystanders, stood by. They were each slow to act in her defense but ultimately were able to stop the attack. She has since sued McDonald's for the absence of staff and management training on how to handle these types of altercations with customers, which happens more often than one would imagine in the fast-food industry.

I share this story as an introduction to the context of this book. In addition to owning my own business for many years, I have also spent over 30 years growing my career in corporate America. Throughout my journey from an administrative assistant to the top Human Resources executive for various organizations, I experienced various levels of discrimination, bias, and inequality in the workplace. This is not something Black women tend to share openly, but rather vent privately to their friends and family while attempting to keep a cheerful

face for the public. Through generations of the same types of experiences, we have learned to deal with them and move on, frequently resulting in Black women leaving viable jobs to start over somewhere else, all in the hopes of finding fair and equitable treatment. Our search can prove successful, but it can take multiple attempts and much longer than the time it takes our White counterparts to reach that desired career success level.

This book will walk you through the strategies I developed and put in place to manage my career and accelerate; rising from an administrative assistant to a Vice President of Human Resources in seven years, tripling my income along the way. Over time, I learned how to "*Stop Being the Best Kept Secret®*" in business and how to be a more significant player on the corporate field by implementing these five (5) proven strategies: **Own Your Power, Own Your Truth, Own Your Healing, Own Your Worth, and Own Your Destiny**. I have since turned these strategies into a top-rated coaching and coach certification program, as well as live and virtual one-day masterclass events.

For this book's purpose, I interviewed other influential Black women who had to overcome their own adversities to propel themselves to their highest levels of success. They have learned how to implement these same strategies in their own way within their careers and businesses, and are examples of the pure grit and determination each of us possesses that can be used to assume our rightful place in the workplace

every day. Overcoming "glass cliffs" (*risky assignments*) and intersectional invisibility *("the tendency to be overlooked, disregarded, or forgotten due to one's status as a member of two underrepresented and devalued groups" – Harvard Business Review*) have made many of these women trailblazers in their careers, not to mention being the "Onlys" (only woman; only Black woman; only Black person). Should we remain authentic or assimilate? Should we attend the team's happy hour and other social events, further highlighting our "Only" status, or do we opt to go home, resulting in isolation and being invisible when it is time for consideration for promotions? These are but a few of the questions we face daily in corporate America.

One of my lessons learned through these interviews has been how similar our experiences have been and how we have instituted similar strategies on our path to success. It is great to realize you are not alone, which is one of this book's true intentions. **You are not alone.**

These stories will take you on a journey of resilience shared through raw and candid personal stories about the Black woman's experience in various industries, including corporate America, government and entrepreneurship. You are part of our community now. Welcome!

x

"The most disrespected person in America is the Black woman. The most unprotected person in America is the Black woman. The most neglected person in America is the Black woman." ~ Malcolm X

TABLE OF CONTENTS

My Story

Dr. Tana M. Session
Copyright 2020
Working While Black: A Woman's Guide To Stop Being the Best Kept Secret

Working While Black: The Plight of the Black Woman In Business

The Interviews

Dr. Tana M. Session
Copyright 2020
Working While Black: A Woman's Guide To Stop Being the Best Kept Secret

MY STORY

My Beginning

I was born into the foster care system of New York City in 1969. My parents were both 17 years-old and had only been dating for a short period. Neither one of them was prepared to be parents. I was my mother's second child. She gave birth to my oldest brother at the age of 15. He was adopted by her godparents, who could not have children of their own. At the time, my maternal grandfather was a single parent raising four children alone, so taking care of a baby was just not feasible. My father's parents were not only taking care of their three children, but my oldest aunt also became a teenage mother, and they were taking care of her son as well. The agreement between the three parents was to send my mother to a home for unwed mothers and have me placed into foster care upon birth. By the following year, my mother was pregnant for the third time and gave birth to my younger brother, who was raised by his paternal grandmother. None of my mother's children had the same father, and we would not meet for the first time as siblings until well over 15 years later.

I remember my foster family, both fondly and traumatically. My foster mother was warm and motherly. I know she was married, but I do not have any memories of her husband. She also had a son, who was around 13 years-old, and a daughter,

who was about nine years-old. I remember playing with them, but I also recall being molested by my foster brother while my foster sister watched and encouraged the abuse. I never told my foster mother about these acts of violence. I was afraid they would get rid of me, which my foster brother threatened me with frequently. He and his sister would tell me I was an ugly Black girl, and no one wanted me, and I believed them. You see, my foster family was White, and I always knew there was something different about me compared to them. Still, the only time I felt different was when my foster siblings were being abusive and saying those ugly things to me as a way to threaten me into silence. Well, it worked for many years.

Often, people ask me how I remember things in such detail from such a young age. My answer is always the same. When you experience trauma, you either shut it out or remember it, especially if the memory impacts the rest of your life. My earliest memories are from the age of two to almost four years old, when I was reunited with my maternal family.

I specifically recall a supervised visit with my mother at the foster agency. I remember walking down a hallway with a woman, my social worker, holding my hand. I had on a dress and little White socks with frills around the edges. As we walked down the hall, my social worker explained that I was going to see my mother. I was confused but held her hand tightly as we made the journey to the visitation area. We arrived at a room with multiple round tables with attached benches, much like a school cafeteria. When we entered the

room, the social worker gently nudged me in my back and told me to say hello to my mother. I was frozen and did not want to leave her side. My mother was beautiful, and as she knelt to embrace me with a big smile on her beautiful brown face, I ran towards her and fell into her arms. At first, the embrace felt awkward, but I remember she smelled so good and felt warm and safe. I would remember the smell of her Egyptian musk oil until I met her again many years later.

Eventually, my grandfather remarried and had two more children with his new wife. They decided to relocate from Brooklyn, New York, to Sumter, South Carolina, to provide a better life for the four youngest children. My grandfather knew my mother and father were still not in a position to care for me, so he asked them to let him and his wife adopt me. My mother would not agree to full adoption, but to get me out of the foster care system, she granted her father full guardianship. He left his two oldest children, my mother, and her brother, in New York since they were both young adults. Most of our family was based in New York, so he knew they would have a good support system around them after he moved.

My next memory is our car ride to South Carolina. Before leaving Brooklyn, we stopped to say goodbye to my father's parents, who lived in the building across the street in the Carnarsie projects. My paternal grandmother gave us fried chicken with White bread wrapped in aluminum foil. I still remember the smell of that fried chicken so vividly. Over the

4

years, whenever I smell fried chicken wrapped in aluminum foil with that slight layer of moisture from the trapped steam, I am taken back to that car ride.

Eventually, I told my grandparents about the molestation. I was around five years-old and did not have the proper words for what happened to me, but I demonstrated it. I recall the look on my grandparent's faces, and their response was to let me know I would never see that boy or that family again, so I should just forget about it. At the time, that made perfect sense, but as a teenager, I would later ask my grandfather why they never reported the incident to ensure the abuse never happened to another child. My grandfather admitted he was shocked and saddened by what happened to me and said he felt somewhat responsible. He shared with me his only thought was the hope I would get older and forget about my foster family and the molestation. When I shared all of my earliest memories with him, including the fact I remembered their last name, he was amazed.

My light-skin completion and light auburn hair was an issue for my grandfather's wife, who was of darker complexion, as were her two children she had with my grandfather. Since a White family had raised me for almost four years, I tended to connect with White friends and favored my White teachers over my Black teachers. I actually got in trouble in kindergarten because I would not let the Black teacher's aide help me or push me on the swings. I only wanted my White teachers to help me. When my grandmother found out about

5

this, she quickly let me know that although I was light-skinned, I was not White. From that point, she would force me to play outside in the hot South Carolina sun to "get some color," as she would call this exercise. She made sure to have me back inside before my grandfather came home from work. I could only come inside to use the bathroom. I had my lunch outside and drank water from the water hose attached to the back of the house. My younger uncle would play with me outside, but he was allowed to sit under the carport in the shade or go inside whenever he wanted a break from the heat.

I also had kids in school who would tell me that I thought I was White, or that I "talked White" because I hung out with White friends and was in accelerated classes where I was usually one of maybe two or three other Black students in the class. My book smarts were a sore spot for the Black kids at our small school. I usually did a good job ignoring them, but I felt isolated and was bullied quite a bit, especially by the darker complexioned kids. In the third grade, I made friends with one Black girl, who was a darker complexion than me, because I stopped a boy who was a bully from pulling her long hair. She had just moved to South Carolina from Florida, and fortunately, we have been friends ever since, over 30 years now. We often laughed about our experiences together in school and how there was such a divide between light-skin and dark-skin students, but we were able to see past those issues and have remained friends in spite of the hate others tried to embed in us.

One of my first crushes in elementary school was our Principal's son, who was in my class. He and I would play together and push each other on the swings during recess. One day we went to his father's office, and he told his father he wanted me to be his girlfriend. I remember standing next to him looking at his father's reaction, and he told his son we can play together, but I would never be able to be his girlfriend because I was Black. He told his father, I was not Black, but rather brown. I was crushed, and soon afterward, he stopped playing with me and made it pretty clear our little romance was over.

Little did I know that my personal experience with bullies so early in life would become part of my passion as an adult in corporate America and as an entrepreneur. My drive to help people stand up for themselves and not let what others may have said about them or done to them, especially as children, stop them from succeeding in life has become a pillar of the work I do.

Before their deaths, I had the opportunity to write a heartfelt letter of gratitude to my grandparents for taking me in and raising me as one of their own. They provided a good home and gave me wonderful childhood memories. We had beautiful holidays, including Christmas with lots of toys and family vacations spent on road trips visiting family in New York, Philadelphia, North Carolina, and other parts of South Carolina. I am still in awe of how my grandfather was able to take care of all seven of us on his postman's salary while

keeping my grandmother as a full-time homemaker. I often felt like I was my grandfather's favorite and took full advantage of his love and protection. He was a great father figure in my life since I did not meet my father until I was a teenager.

My mother eventually relocated to South Carolina when I was around nine years-old. One of the first things I noticed about her that day was her beauty and smell, the same Egyptian musk oil I smelled during that supervised visit when I was two years-old.

I was enamored by her every move and quickly placed her on a pedestal. I wanted her all to myself and bragged at school that my mother lived with me at my grandparent's house. I no longer felt like an outsider in school. At one time, I was being raised by grandparents with neither of my parents in my life. I was teased often for multiple reasons: light-skin, light auburn hair, skinny, taller than most girls, uneven teeth, called an orphan. You name it, and I was teased about it. I was made to feel unwanted all over again by some of the schoolyard bullies. I had to learn to have tough skin and learn how to fight.

My mother eventually moved out on her own but did not take me with her. I remember her explaining to me the reason she wanted me to stay with my grandparents was that she needed to "get on her feet." I learned years later she was still not prepared to be a full-time mother. She wanted her freedom, which became a cause of tension between her and my grandparents, resulting in the ultimatum of following their

house rules or moving out. She chose the latter. I was crushed, but luckily she only moved around the corner from my grandparents. I was allowed to walk to her house and spend the weekends with her. There were times when I would beg my grandfather to let me go live with her, but he was adamant that she was not ready and still needed to "get on her feet." After spending a few weekends with her, I quickly realized why he did not want me to live with her. My mother loved to party, and taking care of a young daughter interrupted her plans. After some years, I finally moved in with her, but our relationship quickly took a turn for the worse.

She was physically, verbally, and emotionally abusive to me. She treated my younger cousins and other children in the neighborhood ten times better than she ever treated me. I felt I could never please her, no matter how hard I tried. I kept good grades and was an honor-roll student. I was a track star. I kept the house clean and learned to cook most of our meals. I tried my best not to talk back to her or do anything to get her upset, but I frequently felt my mere existence upset her.

Of course, I complained to my grandfather, usually on Sundays when he would pick me up and drive me to church. Sometimes he would have her come to his house to meet with him to discuss her behavior and share his disappointment with her. My youngest uncle and I would hide in the hallway and listen in on those discussions. My mother became a different person, taking on a teenager's persona in trouble with her parents. She would lighten up on the abuse for a while

following those "come to Jesus" meetings with her parents, but the change never lasted.

Over the years, my mother dated quite a few men, some of whom made inappropriate sexual comments to me as a pre-teen and young teenager. I also saw my mother abused by some of her boyfriends. The worst incident was when one of them hit her with his car as she was trying to run away from him after they started fighting in the middle of the night. I was awakened by them arguing in the bedroom. I heard her run out the door with him following closely behind. I looked out my bedroom window and saw him following her in his car with the lights turned off. He kept speeding up and slowing down, threatening to run her over.

At one point, she slowed down and staggered; then, he sped up and hit her. She screamed out in pain, and he jumped out of the car and ran to her. I saw him pick her up and place her in the back seat. I didn't know if she was dead or alive. They never came back home, and by the time my alarm went off for school the following day, she still was not home. I went to school and when I returned my aunt was waiting for me at our apartment. My heart was beating fast because I automatically thought she was there to tell me my mother was dead.

Instead, my aunt informed me my mother was in the hospital with a broken leg, and the police wanted to interview me since I was home when the fight occurred. My aunt worked at the only hospital in our town, which is how she found out her sister was taken to the emergency room in the middle of

the night. She asked me if I had seen anything, and I told her everything. When I arrived at my mother's hospital room, she asked me the same question. Her boyfriend was there as well. He looked like he had been crying all night. I really liked him, he was good to me and even taught me how to drive, and I didn't want him to get in trouble. I told them both what I had seen and heard. My mother insisted I could not tell the police because they would take me from her, and I would end up in foster care until "those White people" decided if I could live with her or my grandparents again. I knew I did not want that to happen again, so I lied to the police and told them she fell as she ran away from him, which aligned with the story they both told.

After years of being in and out of jail for petty crimes and on and off drugs, my father called to announce he was getting married. He wanted to invite me to his wedding. My mother denied his wish, but a few years later, she called to let him know she was sending me to New York on a one-way bus ticket. At the age of 13, my mother decided it was time for him to assume his responsibilities as my father. She and I were still bumping heads, and she was not thrilled with me reporting her behavior to my grandfather. She told my father she needed a break, and it was his turn to take care of me since he was able to get himself together, get married, and take care of another woman's child. He and his mother told my mother to pack my suitcase and send me on the next available Greyhound.

11

I moved back to New York and lived with my paternal grandparents. We lived in the same apartment in the Carnarsie housing projects they lived in when I left there as a four year-old on my way to South Carolina. My father and his parents decided to have me live with my grandparents because they lived in a better school district than my father and his new family. I had gotten to know my paternal grandparents over the years through phone calls, money sent in cards for my birthday, Christmas, and back to school shopping, and summertime visits, so they were no strangers to me. My grandmother spoiled me, and my grandfather liked to walk me around the neighborhood and buy me anything I asked him for while showing me off to all of his friends. I was my father's only child, and my father was their only son, which made my relationship with his parents that much more special.

This time, for some reason, I did not feel awkward going to school and telling people I lived with my grandparents. I believe it was because by now, I knew my parents, and I spent the weekends with my father and his family. He spoiled me and was so proud of me. He and I had a great bond, although I felt weird calling him "Dad" since I never called anyone that before. I called my mother by her first name, "Denise," which she requested shortly after her move to South Carolina. I never called her "Mom." This struck many people as odd, but in hindsight, it said a lot about our relationship.

I attended ninth grade at Canarsie High School and got my first job through the New York City Summer Youth Program,

which was my first introduction to being a Black female in corporate America.

I share my humble beginnings with you not to garner sympathy or to make myself out to be a victim. I share this with you because it fuels my vision for empowering other women who have been abused, marginalized, bullied, ridiculed, or in other ways made to feel invisible. I share this with you to know that regardless of your past or present conditions or situation, your future is entirely up to you. It doesn't matter where you start. It's all about where <u>YOU</u> see yourself going! Remember...you are <u>NOT</u> alone!

The Working Years

I think it is only fair to start this book off with my OWN story of discrimination, inequality and unfair workplace practices. My first job was at the age of 13 in Brooklyn, New York, through the New York City Summer Youth Program. I was a summer camp counselor for elementary school-aged children. Then, during the summer between my junior and senior years of high school, I worked at a local Burger King restaurant. In my senior year, I secured co-op jobs through a high school program for high-achieving disadvantaged youth. The first position was as a clerical assistant for a personal injury attorney in Brooklyn, New York. I eventually moved on to another co-op position as a bank teller at Apple Savings Bank in Brighton Beach, New York, a predominantly Russian immigrant neighborhood in Brooklyn.

The entire staff at the bank was White, except for one other bank teller and me. She and I were both light-complexioned Black women and classified as "professional" by our manager. We were both frequently complimented by staff and banking customers on how well we dressed and spoke. Neither one of us found this complimentary, but rather insulting and isolating, which we openly discussed with each other over

lunch and after hours on our train ride home. None of our White counterparts received this type of feedback, so what made us so different?

What she and I quickly noticed was how we were treated differently from our White peers. Although we were all female bank tellers, the two of us were not allowed to rotate to the business clients, which was a key position leading to promotion opportunities. When we asked our manager about the lack of opportunity to service business clients, she told us since most of the clients were fluent in Russian, they felt more comfortable working with tellers who spoke Russian. Of course, this ultimately limited our opportunities for growth as the only two Black bank tellers at this branch. Over time, we also noticed the manager never hired any darker-complexioned applicants from other high school co-op programs when they came in for interviews. She always had an explanation for her decision in the team meetings, but my coworker and I knew the real reason; they were intimidated by dark-skinned Black people. We both witnessed Black people being mistreated whenever they came into the bank asking for change, directions, or questions about opening a bank account. This behavior was blatant and uncomfortable for both of us and reminded me of my own experiences with racism as a young girl growing up in South Carolina. We both started planning our escape from Brighton Beach in hopes of landing new jobs in companies where this type of discrimination was neither accepted nor tolerated.

Dr. Tana M. Session
Copyright 2020
Working While Black: A Woman's Guide To Stop Being the Best Kept Secret

After two years in Brighton Beach, I applied for and secured a bank teller position with Chase Manhattan Bank located at Rockefeller Center in midtown Manhattan. With the exception of experiencing my first and only bank robbery (which scared me to death), I loved working for the company and excelled in my professional development. That position catapulted my career in corporate America. After working as a bank teller for a couple of years, my manager recommended me for a position in a newly formed department within the direct deposit processing division.

I landed the back-office position in their lower Manhattan location. I reported to my first Puerto Rican manager, which I was initially excited about, but quickly learned he had his own way of isolating the Black employees while only promoting White and Puerto Rican employees. Again, I was one of two Black employees in this new division. My counterpart was a very light-complexioned Black man with curly hair and green eyes. Based on our complexion, professionalism and ability to dress the part, we fit in quite well. However, we both quickly assessed the level of favoritism in the department.

Our manager gave us low-level tasks, including keeping the office supplies stocked and staying late to ensure the automatic drafts were processed accurately after midnight. Since direct depositing was a new process and system, there was still a bit of manual processing involved, which my Black male counterpart and I were responsible for handling. Admittedly, he and I did not have our college degrees at the

16

time, which was one reason we were told why we had to do the team's lower-level responsibilities. The caveat was that we were all hired onto the team at the same time based mostly on our prior banking experience, and we all received the same initial training since the division was new. This fact made it that much more difficult to understand why the responsibilities were not shared equally with the same level staff members. The key difference was how our manager treated the Black employees, which was evident to our peers and openly discussed when we got together for happy hour after work. Of course, come Monday, no one talked about the workplace discrepancies and went back to their corners to perform their respective roles. I lasted two years there before moving on to an administrative assistant position with the investment firm PaineWebber.

<div align="center">+++++++++++</div>

Working as an administrative assistant on Wall Street for PaineWebber in the early 1990s was an interesting time. I worked on the trading floor and was exposed to smoking in the office, rude and crude language, sexual harassment and verbal abuse. There were only White men on the trading floor at this time, and the only women there were three other administrative assistants and me. Each of us was assigned to groups of traders. We ordered their breakfast, lunch and sometimes dinner and cleaned up their desks at the end of each day; we were at their beck and call throughout the day.

I had gotten married for the first time shortly after graduating high school and would go home and tell my husband about the office antics. He understood what I was going through because he worked in the maintenance department for Bear Stearns, another large investment firm at the time. He saw firsthand some of the same behavior happening at his company. He was almost able to operate there as a ghost because he was a Black man in a maintenance uniform. Most times, people would treat him as if he were invisible. He shared with me that it was demoralizing at times because he always treated everyone with respect, but that respect was not always returned. He shared with me that he felt like some of the White employees spoke to him as if he was their personal servant and asked him to do simple tasks they could easily do for themselves, but he would smile and complete the task and come home and share his experiences with me as well. We quickly realized if you were not a White male or married to one who made a lot of money on Wall Street, no one respected you.

I cannot honestly say I was treated differently at PaineWebber because of my race, but gender was definitely a factor. The four of us assistants would go out for drinks after work, along with our supervisor, who was an older mid-career White woman and talk about the bad behavior we dealt with in the office. Having our butts grabbed, being called "doll" or "honey," was normal and acceptable office behavior. Our supervisor told us just to be nice and not to make any trouble,

Dr. Tana M. Session
Copyright 2020
Working While Black: A Woman's Guide To Stop Being the Best Kept Secret

or we could lose our jobs. The pay was good, but it came to a point when I had to ask myself whether or not the salary was really worth it.

Ultimately, I decided it was no longer worth it. I left PaineWebber for a new job as a receptionist for The ALMI Group, a diversified entertainment company involved in motion picture and television production and distribution; video games; vending machines; and videocassette rental and sales outlets. They also owned RKO Century Warner movie theaters before selling to the well-known Cineplex-Odeon chain.

+++++

My time at The ALMI Group was educational. Let me first say I learned a LOT at this company about how to be an executive-level assistant. As the new receptionist, I had to cover for the Executive Assistant to the co-CEO. She was terrified of her boss, as was everyone else at the company. He led by fear and intimidation, compared with his partner, who was one of the kindest and most even-tempered people I had ever worked with at the time. The COO was a jittery older gay White man who was in fear of getting fired every day. Whenever anything went wrong, he would bear the brunt of the co-CEO's verbal attacks, and sometimes physical, as he was known for throwing a stapler, tape dispenser or any other desk supply he could readily get his hands on.

I received specific training before being able to cover for his executive assistant's restroom and lunch breaks. I learned

19

rather quickly how to avoid any missteps while dealing with him. The other two executive assistants who worked for his partner felt sorry for me and would check on me often during any of his assistant's extended leaves.

During one of her intermittent "mental health" leaves of absence, she decided not to return. I was petrified! After receiving her medical leave notification, he called me into his office and said he was sending me to a class to learn shorthand and expected me not to waste his money. He went on to say he was doubling my salary, I would be his new executive assistant effective immediately, and informed the COO to find a new receptionist. There was no negotiating, and no one was going to tell him "No." Transitioning to this new position is how I learned how to be a stellar executive assistant. This forced situation goes to show that what does not kill you only makes you stronger. You can even learn life lessons from a bad boss.

In addition to the hostile work environment caused by his unpredictable mood, he showed no empathy when I lost my mother to cancer and had to go to South Carolina for her funeral. While there, my husband moved out of our apartment and took everything except my clothes. When I returned to New York, I had no place to live and had to move in with an aunt I did not really know. I shared all of this with my boss, hoping he would be sympathetic and understanding of what I was going through. Three months later, my father passed away from HIV-AIDS, and I remember him screaming out loud for the entire office to hear, "Again? You have to be

Dr. Tana M. Session
Copyright 2020
Working While Black: A Woman's Guide To Stop Being the Best Kept Secret

out again?" I was in disbelief and knew I would not be there much longer.

I suppose I should not have been in shock. When one of his best friends died, he and his wife stopped by the office on their way to the funeral. I told them both I was sorry for their loss and brought in some coffee for both of them. While she waited in his office for him to collect some paperwork, his wife started crying. He turned to her and said, "Stop crying! He's dead already!" I slowly backed out of the office and closed the door.

I secretly started looking and interviewing for a new job immediately. Within a month, I resigned and moved on to a new position with The Children's Television Workshop as a Public Relations Assistant for Sesame Street. They were conveniently located on the top floor of the same building as The ALMI Group. When I turned in my resignation letter, the COO begged me to stay and said my boss wanted to offer me more money. I told him it was not worth it to me and my sanity—and I left.

Dr. Tana M. Session
Copyright 2020
Working While Black: A Woman's Guide To Stop Being the Best Kept Secret

The Children's Television Workshop (CTW)

I thoroughly enjoyed my time at CTW. The Public Relations department was run by two Black women who quickly took me under their wings. Our team was young and innovative, and we were allowed a fair amount of autonomy. For the first time in my young career, I had not one but two Black female bosses! These women were beautiful and intelligent and shared their knowledge willingly with the four PR Assistants on the team, one young White woman, two other young Black women, and me. I had never worked on such a diverse team, and I felt I was really starting to come into my own as a professional woman in corporate America.

My role as a Public Relations Assistant consisted of reviewing nationwide newspapers for all mentions of any of our shows and creating a daily newspaper clipping report for our Executive Director. I also helped draft responses to fan mail for some of the Sesame Street puppets. Additionally, I was a handler for various celebrities who were guests on Sesame Street and had the opportunity to experience the behind-the-scenes magic of the show's puppets and actors.

I was also able to travel for the first time as part of my position. I was the escort for the Cookie Monster costume,

which took me to Sacramento, California, and Roanoke, Virginia, for the first time in my life. Here I was with no college degree, traveling cross-country for business and rubbing shoulders with celebrities as part of my daily responsibilities. Although it always bothered me, I began to doubt the absolute need to go back to school; plus, I did not have money to pay for classes and did not want to take out student loans.

After almost two years with CTW, our Executive Director came under investigation over her high six-figure salary. Since viewer donations and government funding funded CTW through the Public Broadcasting System, it was deemed inappropriate for her to have such a high salary. My managers saw the writing on the wall and knew the entire company was in trouble. They had high salaries, too. One of them resigned and moved to Virginia. Then my coworkers resigned, and the feel of the team and the company culture started to change. The Executive Director was eventually terminated in an effort to take the negative focus off of the company and its children's shows, and a new Executive Director was hired.

The one Black female manager who was still there told me to start looking for a new job because she had accepted a new one and would be leaving shortly. By now, the entire team was gone except the two of us. She had a one-year-old baby at home, and at the age of 40, she could not afford to be without a job. She and her husband lived a comfortable lifestyle on Long Island. I had helped plan her baby shower and had become close to her family. She was the oldest

person I had ever met to have a baby, but I later learned she had married late in life and decided to pursue a career before starting a family. I took her advice, and I started looking for a new job, too.

My options were limited since I still did not have a college degree, but I was able to land the job with Ernst & Young after a few interviews. This whole time, I worked part-time as a hostess for Houlihan's Restaurant, located on our building's first floor. I needed the extra income because I took a pay cut to work for CTW after leaving The ALMI Group. I had also moved into a new apartment with a roommate after my husband had left me homeless. Fortunately, my new salary at Ernst & Young enabled me to resign from both CTW and Houlihan's on the same day.

Dr. Tana M. Session
Working While Black: A Woman's Guide To Stop Being the Best Kept Secret

The Ernst & Young Years

I like to tell people Ernst & Young is where I cut my teeth in Human Resources. In my first position as a floating secretary, I was responsible for filling in for any administrative assistants who called in sick or went on vacation. When not on an internal assignment, I provided support to the Director of Personnel and other managers and supervisors on the Human Resources team, which is where I spent most of my time. As a result, the Director of Personnel, who was newly promoted, asked me if I wanted to be her administrative assistant, and I jumped at the chance. She and I had developed a great bond, and she was already starting to take me under her wing. I considered her to be my first mentor and soaked up everything she shared with me about her work. I came in early and stayed late, I kept her organized, and I made it my mission to make her look good.

Eventually, my boss gave me additional duties. I was responsible for conducting the typing tests for administrative assistant candidates, and I also led new hire orientation for recently hired administrative assistants. Partners and other key stakeholders began to know my name and developed a level of trust for me and the quality of my work. I enjoyed my HR team members and got along well with the other managers and supervisors on the team. I benefited from the "halo effect"

Dr. Tana M. Session
Copyright 2020
Working While Black: A Woman's Guide To Stop Being the Best Kept Secret

because I felt I knew how much everyone liked me without any strings attached. Now, of course, I did the work and dressed the part, making sure my "i's" were dotted and my "t's" were crossed. I left nothing to chance because I wanted to make certain I always made my boss/mentor look good.

After almost three years with Ernst & Young, I got married for the second time, and my new husband and I wanted to relocate to Atlanta, Georgia. It was the mid-90s, and a lot of young Black professionals were making the move to Atlanta. There were opportunities available to Blacks in Atlanta that seemed like a dream in other parts of the country. I had a close friend who had relocated a year prior and was enjoying all of the benefits of being in a predominantly Black city. She and I had been coworkers at The ALMI group and kept in touch after she resigned as the receptionist they hired to replace me when I got promoted. My boss supported my decision and actually helped me land a job with The Coca-Cola Company since Ernst & Young only had a small satellite office in Atlanta at the time and did not require an administrative assistant.

After my boss connected me to the executive assistant, then to the CEO of Coca-Cola, I booked a flight. After attending a full day of interviews and tours of the company's world headquarters in Atlanta, I immediately understood why my girlfriend was adamant that I needed to move and start my new life there. My husband was confident Atlanta would be where he would make his first million dollars. Anything was possible there for Black people at the time. We honestly saw

no limits to what our future could look like. I landed the job as an administrative associate and maintained my New York salary, which was unheard of back then for someone at my level with no college degree. Having a close relationship with the CEO's executive assistant had its privileges. It was July 1994, and my husband and I packed our car and a moving truck with all of our belongings and made the 16-hour drive to Atlanta from Brooklyn, New York.

The Coca-Cola Years

I started my career at Coca-Cola in July 1994 as an administrative associate. Eventually, Coca-Cola decided to develop career paths for the administrative staff, and I was promoted to a senior administrative associate. Another administrative associate started the same day I did, a White woman, who was also promoted to a senior administrative associate. What I did not know at the time was she was paid more than both new and current administrative associates from the time she was hired. Our duties were the same, and we supported the same number and level of managers. The only difference was she had a degree.

At the time, having a degree was not a requirement for any of the administrative roles. The determining factors to be promoted to the new administrative level were as follows: years of experience plus the level of the individuals we supported, and a skills assessment based on an Administrative Skills test we had to take. Little did I know at the time, this sample of unfair and discriminatory practices was only the tip of the iceberg of what was happening at the iconic Coca-Cola Company.

During my employment there, I became pregnant. I previously experienced an early-term miscarriage, so this

28

pregnancy was considered high risk since it happened so close to the miscarriage. I notified all three of my managers, one of which had four children, and was extremely happy for my husband and me. He was one of the few Black Directors in the entire company, and we were very close. My other director, a White male, was married with children and congratulated me as well. However, I had one White female Director who turned venomous when I announced my pregnancy. She even asked me if I was too young to start having children, especially since I had been married less than two years at the time. She expressed nothing but negative comments during a time that was supposed to be celebratory for me.

In our weekly one-on-one meetings, she tried to come across as someone genuinely concerned for me. She would tell me I had such a bright future ahead of me and maybe now was not the time to start a family. I felt she was secretly hoping I would have another miscarriage or perhaps consider having an abortion. I was devastated. Throughout my pregnancy, she made my life a living hell. Suddenly, I could never do anything right, whereas before, I had exceptional reviews and feedback from my entire team, including her. Not only was I pregnant, but I was also taking college courses toward my undergraduate degree, which I had started and stopped a few times over the years since graduating high school.

Coca-Cola had a partnership with a college located an hour away from our campus headquarters. Two days per week, I had to leave work an hour early to ensure I made

it to class on time. This early departure was an issue for the female Director. However, my other two male Directors were perfectly fine with my schedule adjustment, and they were impressed with the fact I planned on attending school throughout my pregnancy. As husbands and fathers, they were probably a lot more sympathetic and empathetic towards me than she was since she was single, in her early 40s, and unmarried.

Because of her watchful eye, I made certain to double-check all my work. I usually went above and beyond for each Director since they were so accommodating, but particularly with her, because I was nervous about making mistakes.

Then one afternoon, when I was about 7 ½ months pregnant, I realized I had not felt my baby move at all that day. We had a routine. He would move and kick me during my drive to work, and then again around lunchtime, and during my drive home. By lunch, I realized there was no activity happening in my belly. I called my husband and told him I was going to the emergency room and he should leave work and meet me there.

It was a frightening moment not knowing what was going on. My baby's heartbeat was irregular, and my blood pressure was extremely high. The doctor asked me if I changed my diet or was under any new stress levels. I told him about my work situation. I told him I thought I was handling it well, but he insisted on putting me on medical leave and bed rest until my due date. I was scared I would lose my job, but I knew the law,

and I had protected status due to pregnancy being classified as a disability.

My two male Directors were sympathetic. They each witnessed the unnecessary pressure the White female Director was putting me under. I decided to file a complaint with the Human Resources department against her as additional insurance for my job security while I was out on leave.

I took time off and had a healthy baby boy. When it was time for me to return to work, I did not want to leave my baby with a sitter for eight hours a day, so I took advantage of a little-known benefit Coca-Cola offered at the time: Job Sharing. I was the first employee to take advantage of this program, and it was the best thing I ever did.

Job Sharing allowed me to work part-time, but part of my responsibility was to find my replacement for the remainder of the week. During this time, Coca-Cola had a pool of internal temporary administrative assistants, one of which covered for me during my medical and maternity leave. I confirmed with my Directors and the Human Resources team that she did a good job covering for me, so I asked her if she would be interested in working three days per week, which would entitle her to benefits. She agreed, and my Directors accepted the arrangement, so I was able to work every Monday and Tuesday, go on my husband's medical benefits and be home with our newborn five days a week. I no longer took classes since that benefit was no longer available to me as a part-time employee, so my degree completion went on the back burner again.

The female Director was very icy toward me upon my return from leave. I learned she was given a verbal warning based on my complaint. The HR team was able to verify her behavior towards me by interviewing other employees, including my other two Directors. When I was in the office on Mondays and Tuesdays, she never gave me any work, which was fine by me.

During this time, I was unexpectedly contacted by an attorney who said they were representing a class action lawsuit on behalf of a group of Black Coca-Cola employees based on a discrimination claim. My name was provided to them by the main defendant in the case. This was a bombshell case against one of the oldest and largest employers in Atlanta. I went in for my deposition and was told I was qualified to be included in the discrimination class action lawsuit. This was based primarily on the fact that the White woman hired at the same time I was hired, was for the same position but with fewer skills. She was paid more than me and received higher raises even though our performance ratings were the same. I also supported more senior managers than she did. There was no valid reason for her to make more money than me.

I was blown away. I had no idea this was going on in the company, and except for the White female manager I had difficulty with, I had a good experience at Coca-Cola. By the time the case was settled, Coca-Cola had to compensate me for lost wages and pay for continuing education courses. This was a five-figure settlement that came out of nowhere! I was

still employed with the company as this case was going on. We were instructed to let the lawyers know if we experienced any form of retaliation since our identities were supposed to remain confidential. Some of us in the class-action lawsuit were still employed with the company when the case was settled.

I continued my Job Sharing position for a year and started taking college classes again using the continuing education funding provided through the lawsuit. Eventually, I resigned from Coca-Cola and became a full-time entrepreneur with my husband in a new retail business we founded, which was doing very well at the time.

New York – The Remix

After my son started preschool at the age of three, I convinced my husband I needed to complete my degree, and I began taking classes toward a degree in Fashion Merchandising. Unfortunately, yet again, I never had a chance to finish my undergraduate degree. Instead, I put my plans on the side, became a housewife, and for almost eight years, I ran multiple successful businesses with my husband. I thought I would never have to return to corporate America, but as fate would have it, I did. It felt like starting completely over and still with no college degree.

By the time my son was seven-years-old, my marriage was over. My husband cheated on me multiple times, got hooked on drugs for the third time, got in trouble with the law, and had to go back to his family in London, England, to clean up his act. I was left with an expensive house, multiple cars and huge debt. I put the house up for sale, sold off the cars, except for the brand-new Acura SUV he leased for me that year, and I filed for bankruptcy.

I had an estate sale and sold everything I did not feel my young son and I would need to start our life over in New York. I placed all of our remaining furniture in storage, not knowing if I would ever see it again. I packed whatever I could

into that SUV and drove non-stop to New York. I knew I had a support system there, and I needed to be near my family. My cousin lived in Harlem in a sixth-floor walk-up apartment. She offered me a place to stay and an air mattress to sleep on. Even though I was not on good terms with my former mother-in-law, she allowed me to have my son stay with her during the week so he could go to a decent public elementary school in her Brooklyn neighborhood. He had only attended private school and was used to me taking him to school and picking him up every day. I had to explain a lot to him at the tender age of seven.

We were now on welfare and living out of a suitcase. Meanwhile, I was in the process of divorcing his father, who was still in England, trying to get off drugs and putting his life back together. He asked me to move there, but there was no way I would be at his mercy ever again. I trusted him with our money and our livelihood, and he blew it! I learned a valuable lesson. Women should never let their partner manage their finances without having input and knowledge of what is being done with the money at all times. I have never trusted another man to manage my finances again. This became my North Star for my climb up the corporate ladder throughout my career. I was determined to never be in this situation again.

+++++

I reached out to my former boss from Ernst & Young to see if she could bring me back into the company, but there

35

were no openings at that time. The company was experiencing a hiring freeze in 2003, so she had no leverage to push my resume to the top of the pile. Fortunately, my oldest brother worked for Memorial Sloan Kettering Cancer Center and had a great relationship with the breast cancer center's Chief Surgeon. When he learned of my fate, he encouraged me to apply for a physician's assistant position in this doctor's practice. After running my own enterprise for almost nine years and making seven-figures as a business owner, it was a very humbling experience going back to work for someone as their assistant.

Luckily, I never lost the skills I learned as an executive assistant for the tyrannical CEO I supported early in my career. Those skills helped me, and I was successful in my new position. Each night after work, I would drive to Brooklyn to help my son with his homework, bathe him, put him to bed, then drive back to Harlem. This went on for four months until I finally had enough money saved to get our belongings shipped from Atlanta and move into our own place in Brooklyn. That tiny apartment was one of my most significant achievements as a newly single mother. I never shared any of my struggles with anyone at work. I was embarrassed and did not feel it was anyone's business. I asked my brother to respect my privacy as well. I did not want my boss or anyone else to think differently about me. I showed up on time, was professional, did excellent work and the patients loved me. I came to do my job and keep my private life private.

I met a few ladies who I bonded with, but I never shared my struggles with my boss or his nurse. I just felt it was none of their business, and I did not want to take the chance of being judged or looked down upon because of my circumstances. Over the years, I have learned that sharing your story often helps others open up with their own struggles and helps to humanize us in the workplace. Looking back over time, I probably should have shared my experiences and what I had overcome with the doctor. He was one of the kindest bosses I ever had, and he still asks my brother about me after all of these years.

After about a year, I left the job at the hospital because I was convinced that I wanted to work in the fashion industry following my short stint in college as a Fashion Merchandising major. As a result, I took on a role as the executive and Human Resources assistant for the COO of a swimwear company based in the Fashion District. She was a middle-aged single White woman with no children and no life outside of work. In the end, this career move was a disaster.

Looking back on this experience, I now realize I suffered from imposter syndrome at the time. I tried to overcompensate because I was the only Black employee in the 30-person company, and I was the only one with no college degree. Her former assistant had a degree and decided she would not return following the birth of her first baby. Her husband was a New York City policeman and they lived on Long Island, so she was able to be a full-time mother.

She was able to cross-train me for a couple of weeks before she left for her maternity leave. My boss had zero tolerance for mistakes and put a lot of pressure on me to work at the same level her former assistant performed. However, they had worked together for over five years. She felt the two weeks of training should have been sufficient to swap us out seamlessly. I tried managing up to her expectations, and I consulted with others in the office to see what I could do to please her. But she ruled the entire office with fear and intimidation. There were days when people would stop by my desk and ask me what type of mood was she in that day. We had high turnover during the year I was there, and she blamed it on people not having thick skin and being weak. She reminded me of the White female Director I worked for all those years earlier at Coca-Cola, which were not good memories.

The CEO of the company was based in Toronto, and we all looked forward to his visits. Her behavior would switch to being welcoming, polite and friendly. She would buy catered lunch for the office, and they would leave early for meetings with vendors, which meant I could leave early, too. Over time, managing her mood swings became a full-time job.

At one point, she had asked me to try on some of the new bathing suits to help give her an idea of which ones they would show in Miami at the annual swimsuit fashion show. I did not mind since there were only women in the room whenever I tried them on for her and the team. She would compliment me on my body and tell me I was the only person in the office with

38

the body of a model and could eat whatever I wanted, have a baby and not gain weight, but it didn't feel like a compliment. She was continually worried about her weight and lived off the South Beach Diet because she had lost 50 pounds using it for over a year. I started to feel like we were bonding, and I was finally getting on her good side and not being compared to her former assistant. And even though I was not invited to go to Miami, I had my boyfriend help me put together a soundtrack for the fashion show, which she loved.

Shortly after their return from Miami, I took a week off for vacation and went on my first cruise, The Tom Joyner Fantastic Voyage. I was excited after hearing so many stories on the radio about the parties, concerts and pure antics that took place each year. I had a blast with my boyfriend and his friends, who were on the cruise with us.

After my seven-day cruise, I returned to the office on Tuesday, arriving at my usual time. I was always the first one in the office because I had to drop my son off at school. I had a morning routine of putting my lunch in the refrigerator, making coffee, going through my e-mails and getting my desk ready for the day. This time, my boss was in the office before me, which was unusual. When I passed her office, I greeted her and went to log into my computer, but I was not able to log on.

After a few tries, I was worried I would get locked out and thought perhaps I just forgot my password after being out of the office for seven days. I decided to get a cup of coffee,

but as I passed my boss's office, she called me in. Just as I was about to explain my inability to log into the system, she slid an envelope across the desk and told me this was my last day with the company. She said things were not working out for her with me, and she was providing me with two weeks' severance. I was shocked.

I asked her what, if anything, I could do to change her mind, and she informed me she convinced her former assistant to come back so she would not need me any longer. She said she "took a chance" with me and regretted it because we just were not compatible. That was it. There was no verbal or written warning. She hired someone behind my back while I was on vacation and put me out on the streets. She knew I was a single mother, but that was of no concern to her.

By now, others were arriving, and when I went to retrieve my lunch from the refrigerator, two ladies from the design team were waiting for me. They told me how sorry they were and informed me she had notified everyone on the Friday before my return that she was letting me go, and they were not to tell me anything. By now, the entire company, including the team in Toronto, and some vendors I had built relationships with, all knew I was fired before I did and that her previous assistant was returning to the company. I was embarrassed, angry and scared. I had no savings and could not afford to be without a job again.

I remember the Chief Surgeon at the hospital told me I could come back to work for him anytime. Still, I knew I wanted

Dr. Tana M. Session
Copyright 2020
Working While Black: A Woman's Guide To Stop Being the Best Kept Secret

to stay in Human Resources after handling all HR duties at the swimwear company, as well as during the entire time when I ran my own companies. The Chief Surgeon at Memorial Sloan could not guarantee me an HR position since that was not his department, so I reached out to my former boss at E&Y again. We had been keeping in touch, and by now, she had transitioned to a new global HR leadership position. I told her what happened to me at the swimwear company. Fortunately, she quickly got me an administrative assistant position on her HR team, supporting her, a Partner and two managers. Within three weeks, and without missing a paycheck, I was walking through the revolving doors of Ernst & Young's new headquarters in Times Square and onto a path to turbocharge my HR career.

+++++

About five years later, I ran into my former boss from the swimwear company while walking the streets of Midtown Manhattan. I stopped her and thanked her for firing me. By this time, my HR career had taken off, and I was running an HR department for a small start-up firm. She was shocked to see me, and I could tell she did not know what to expect. I asked if she remembered me, and she said she did. I then extended my hand and told her I just wanted to thank her for firing me because it led me to the right career path, and I have no regrets. In that moment I felt empowered and confident after being terminated for the first time in my career, and I walked away with my head held high.

Ernst & Young – The Remix

I was officially a boomerang, which is what E&Y called former employees who returned to the organization. Some of my friends from my first time working there were still there. I eased back into the organization, and it felt as if I had never left. I enjoyed the team I was supporting and was determined to redeem myself from my swimwear company experience. The team appreciated my ability to jump right in and get things done efficiently and started giving me more challenging work and projects. Soon, I was handling projects that gave me exposure to the other leaders in the HR department. After about a year, I had my sights set on moving to the newly formed Experienced Recruiting team.

I excelled in my new position, and my team adored me. I was one of the few Recruiting Coordinators who earned a bonus each year since, at that time, bonuses were primarily for client-facing positions. I took my job very seriously and started developing significant social capital with many key decision-makers. I dressed the part. I had lunch and happy hour with all of the right people. I was intentional and strategic. I learned how to manage my brand so well that even the North American Managing Partner knew my name and greeted me whenever we bumped into each other in the hall. I also joined

the EY/BEAT Employee Resource Group (EY Black Employees Achieving Together) to expand my network beyond HR since most of the members at the time were client-facing staff. Soon, I was promoted to Partner Recruiting and handled the interviewing and onboarding for all of our new North American Partners while training new Recruiting Coordinators in our newly formed Shared Service Center located in Dallas, Texas. I was on fire!

I had both sponsors and mentors. I still kept in touch with my former boss who hired me back into EY, but she traveled so much internationally I rarely saw her. I also remained friends with the other managers I supported on her team and enjoyed happy hour and other social activities with them. Although I had moved on to HR's North American side, I felt it was imperative to keep those relationships close. I was selected to be part of a print campaign E&Y did to promote their recruiting; my face was seen on internal and external marketing materials. I was flying high and felt I had found my forever home.

If I stuck to the career path E&Y had established, my next natural career move would be to a People Consultant, which was an HR Generalist position assigned to a specific business unit. I coveted that role after seeing some of my White Recruiting Coordinator colleagues promoted over the last couple of years. I quickly noticed there were no Black women in that role, but that did not stop me. I just knew I would be the first one! I learned how to play the corporate game, and

I mastered it. I had the "5 out of 5" performance ratings, the bonuses, the social capital, the right mentors and the best sponsors. Still, each time I applied or asked about being promoted, I was told I did not qualify because I did not have a college degree. By now, I had returned to school and was finishing up my degree online. All my managers knew I was working toward completing my degree, but they continued to hold that over my head. I refused to let that deter me. I figured I would have to prove to them that they made a mistake by passing me over.

After almost two years, I was approached by two different HR Directors in other divisions who asked if I would consider joining their HR teams on the client-facing side of the business. I was at a point where I was wondering what was next for me since I was able to do Partner Recruiting in my sleep and was ready for my next challenge. After interviewing for both positions and discussing it with my former boss/mentor, I decided to accept the HR Project Manager position on the Transaction Advisory Services HR team. I was excited to not only move to my first exempt/salaried position, but the team was so welcoming. Each person on the team said they heard so much about me they were looking forward to working with me and were glad I accepted the position.

The position was challenging, and I had to learn advanced Excel skills due to the type of work we were responsible for. Ultimately, in my new role, I helped manage and track our consultants' careers from their hire date up to the path to

44

Partner. I had to ensure they completed all required training, obtained their CPA if applicable for their position, and facilitated the performance appraisal roundtable discussions. Shortly before joining the team, I finished my undergraduate degree, so I no longer had that hanging over me, which gave me an added dose of confidence. Although some people questioned the legitimacy of online degrees at that time, I still held my head high with pride. I immediately enrolled in an online MBA program because I felt I had some catching up to do with my peer group. There would be times later in my career when my online degrees' legitimacy would be questioned, but I never let that hold me back.

Although I was new to this team, I quickly realized this was not the type of work I wanted to do. I started looking for new opportunities and regretted not accepting the other position I had interviewed for a few months before. Whenever I saw a People Consultant position open up, I would apply. Sometimes I would get an interview, but I was often declined without even having a phone interview. I continued to notice there were no Black People Consultants and accepted that I probably would not be the first one after all, so I started looking externally for my next career move. I knew of a few other E&Y employees who told me I would have to leave the company, make more money, get a promotion and *then* return in order to get the type of position I wanted. I took that advice to heart and soon landed my first HR Manager position for a small start-up investment research firm on Park Avenue.

45

After secretly conducting my interviews during my lunch hour, I was offered the position and could not wait to tell my E&Y friends. They were all excited for me. The Black women said I represented hope for the rest of them. It was a happy and sad time because I would miss my friends, but luckily I was walking distance away from the E&Y Times Square headquarters. I submitted my two-week notice to my Director, and she was shocked. Although she knew I did not like the work I was doing and knew I had applied for People Consultant roles, she seemed surprised I was leaving the company. I told her I did not feel there was a real career path for me there, so I had to look externally. When she asked me what I would be doing, I told her I accepted a position as an HR Manager. You could have knocked her over with a feather. The look on her face said it all. She was in disbelief and asked me if I thought I was getting in over my head. I had to remind her that I had run my own business, multiple companies for over seven years, and handled all of the HR duties, so I felt confident taking on this new role.

On my last day with E&Y, I went to lunch with some friends to celebrate that I finally did it! However, that celebration was short-lived. When I returned from lunch, a colleague who sat in the cubicle across the hall from our Director informed me she overheard a conversation about me while I was at lunch. Apparently, our Director was in her office with the door open because she thought everyone on the team had gone to my

46

farewell luncheon. She was heard talking to another Director on the phone about me leaving and about my new position. People were honestly shocked that I was leaving E&Y because I was recognized as one of their Rising Stars and a High Performer, but the system was not built to support my career aspirations.

During her conversation, our Director expressed disbelief that I would be an HR Manager and run an entire department. She even said I must have lied on my resume to get the job. When I heard this, I was hurt, angry, shocked and disgusted. I realized I could handle this one of two ways: (1) I could walk into her office and confront her one-on-one, or (2) I could let her, her boss and our North American Managing Director know I did not appreciate her smear campaign and venomous comments about something that should be celebrated. I chose the latter. On the next page is the last E&Y e-mail I sent right before signing off and turning in my laptop to the IT department.

But first, here is a little more history about this Director. She was a White woman who started her career at E&Y as an administrative assistant with a college degree. She and her husband used to weigh close to 300 pounds but got gastric bypass surgery to lose weight. She had a tendency to comment on how well I dressed and asked why I was always in a suit since it was not required for my position. She also asked me how I could eat the way I did and stay so skinny (again...it didn't feel like a compliment!). She watched me much too closely

for my comfort level. There appeared to be some degree of jealousy on her part.

After sending my e-mail, I walked through those revolving doors of E&Y and never looked back. My former boss/mentor had also moved on to a new company after over 20 years with the firm. She was told she would never be promoted to Principal because she did not have a CPA. That was enough to drive her away, as well.

The Ernst & Young Email That Shook the Entire Organization

Tana M. Thompson/HR/
EYLLP/US
11/30/2007 10:57 AM

Unfortunately, it has come to my attention that you have been overheard discussing my new position on a telephone conversation yesterday in a derogatory manner. I find this behavior to be very upsetting, as I have always respected Ernst & Young as a firm and the manner upon which their professionals conduct themselves; especially when recognizing an employee's opportunity to grow, even if it is outside of this firm. As a People Team Associate Director who rose through the ranks from an administrative support role, I was shocked to learn that someone with your knowledge and expected level of maturity could reflect upon my opportunity in such a hurtful way. I am hopeful that this is the last time an occurrence like this takes place, as I am certain that you are aware of how to conduct yourself in a manner befitting

your current position and responsibilities as a counselor and People Consultant.

With this said, I would like to go on record and request that, in the future, if you must participate in a conversation that involves a member of your team, please close your office door so that it does not fall back on the ears of those whom you are talking about. This is the second time in a month that this has happened, once with the administrative assistant for the team, Tiffany Hill, and now me. I hope that these are rarities and not your normal practice. I sincerely hope you take this under advisement, as I hate to leave the firm with such a tainted view of how personnel matters are discussed by our human resources professionals, as this could easily become a defamation of character legal matter in the future.

Thank you.

Regards,

- Tana

Below is a response e-mail I received from my former boss/mentor when I sent her a copy of my original e-mail. Note the section in bold. Please pay attention to what she is saying and **NOT** saying at the same time, as it relates to someone who looks like me trying to grow a career at E&Y. She did not get promoted to the Principal level because she did not have a CPA, which was required at the time for all Principals/Partners. And I have worn my hair short, natural and platinum throughout my entire second career at E&Y. Still, at the time, there were no Black People Consultants, which was the natural next step in my career after being a Project Manager.

Hi Tana,

I am so sorry this happened to you, especially as you are leaving following a long and successful tenure with E&Y. I imagine there are many reactions people will have to your moving on, and for some who may be jealous, the reactions may be negative. Your response was measured and appropriate under the circumstances. Someone may contact you now to discuss how you heard this information so be prepared for that. They may want to conduct an investigation to determine if this is true and want to interview that individual and whomever overheard the other conversation.

Don't let this get to you though. I am certain there were a number of heads shaking when I left to be the global leader of HR here. **At E&Y, unfortunately, they have a hard time seeing people for their potential if you don't "fit"**

51

the standard model. And you and I probably do not....! It has not stopped me, and it won't stop you either, my dear. Just leave with good humor, don't burn any bridges, and show them what an outstanding professional you are!

Take care and let me know how things are going after you get settled in your new position!

Fondly,

I Finally Made It!

I started my HR Manager position two weeks after leaving E&Y. During those two weeks, I received e-mails and calls from my former Director's boss and the Managing Director asking me to share the backstory of my e-mail complaint. Deep down, I knew nothing would happen to her, but I wanted to go out with a bang and show her who she was dealing with. I had stomached her snide remarks and microaggressions and kept smiling and performing, but I had reached my breaking point. In the end, she got chastised but is still working for E&Y today. However, not getting promoted at E&Y after excelling at my position was the push I needed to move on. Many of my former colleagues, all Black women, who are still there, remain in their same positions or have been let go due to downsizing. I wish they would have left with me...but to each his own.

I embraced my new HR Manager position with open arms. I had the autonomy to create the HR department from scratch, which reminded me of the days I ran my own business. The fact that I had been an entrepreneur was the factor that gave me the lead on the other candidates. I had also returned to school and earned my MBA before completing my first year as their new HR Manager.

Dr. Tana M. Session
Copyright 2020
Working While Black: A Woman's Guide To Stop Being the Best Kept Secret

Additionally, I had gone through a messy divorce from my second husband, which also involved a year-long custody battle, resulting in losing custody of my son for an entire school year. I spent every vacation day in family court during my second year on the job. I privately shared with my CEO what was going on to keep him in the loop, but I did not let my personal affairs interfere with my job.

The company was only five years old with 50 employees, but with aggressive growth plans. When I joined, there was only one other Black employee, the CFO, who was very light-complexioned with fine curly hair. You had to look very closely to determine if he was Black or biracial. I just remember walking in for the interviews and noticing a sea of White people in open-floor workspaces and thinking to myself, "This has got to change!" Most of the employees were children of the CEO's college friends or referrals from those same employees, so everyone looked the same. I eventually built a small HR team and was able to hire more diverse employees, including their first openly gay Black man who stayed with the company for ten years...long past my tenure.

Shortly after starting my position there, my fiancé and I purchased a home in the suburbs of New York. As a result, my commute was over two hours each way. I was ready for a change after about a year of that commute. I started to look for positions closer to home, but there were not many options in Orange County, New York. However, during my search one day, I found a Vice President of HR position located about 30

54

minutes away from my home. The position was for a non-profit healthcare facility. After a series of interviews, they offered me the position. The salary was significantly more than what I was making at my final role with E&Y. Within seven years, I had increased my salary three-fold and was now a senior-level HR Executive!

When I turned in my resignation to my boss, a White man who was the founder and CEO, he was shocked. He understood my reasoning (the commute) but could not believe I would be the VP of HR for a 900-employee company. I immediately thought, "Here we go again! Why do these White people keep doubting my capability?" I had asked him what my career path was after my first year with the company. Admittedly, he did not have one in mind. While there, he promoted quite a few White employees, including two other White women who were Account Managers. Neither one of them had an MBA or certifications. I had completed two HR certifications shortly after finishing my MBA. They ran small teams, but I ran an entire department. I began to feel I would never get promoted there, either. He kept saying he needed to see "more" from me but could not quantify what "more" meant. I felt he would keep moving the goal post to suit him and expect me to continue to rise to the occasion and be satisfied with his vague feedback.

On my last day, he took me to lunch and asked me more questions about my career goals and the company I would be working for. During that lunch, he admitted he did not think I was ready for a promotion and felt moving to a VP position so soon

Dr. Tana M. Session
Copyright 2020
Working While Black: A Woman's Guide To Stop Being the Best Kept Secret

after being a Manager would be a mistake. He expressed concern for me "skipping" the position of Director and going straight to Vice President. I reminded him of my experience running my own seven-figure business for multiple years, which was what attracted him to me for the HR Manager role. I also told him the position with his company should have been an HR Director role, and he said if it had been, he would not have hired me.

When I mentioned my MBA and two HR certifications, he said because I obtained them while working for him, they were a non-factor in his consideration for promotion. I felt like I had been punched in the gut. Had I done all of that for nothing? Why could he not "see" me? Well, there we sat, finally having an honest conversation. He provided surface feedback during my performance reviews over the past three years, but I was, at last, getting some substantive feedback, albeit too late for me.

We ended the rest of our lunch with forced small talk, and it was a quiet walk back to the office. He shook my hand outside of the office building and thanked me for all I did for the company over the past three years. I left and went home on my final two-hour commute from Manhattan that day. I never spoke to or saw him again. Over the years, I kept in touch with the COO, CFO, HR Assistant I hired (a Black woman), and the openly gay Black man I hired. The COO has also served as a professional reference for me more than once, which proves it is crucial not to burn bridges on your way out of an organization. You never know when you may need to reach back for a favor.

My Non-Profit Era

I had officially tripled my income in three years by accepting this Vice President position. What a difference a couple of college degrees, HR certifications and genuine experience can make! There was no looking back. I was used to the corner office, and this new role came with a staff of five with over 900 employees spread across multiple locations. It was a big job, but I felt I was ready.

The entire executive team was older White men and women who had been with the organization almost since its founding. There was one other Black person on the executive team, a man who was in charge of security but had been handling HR for the past two years while they looked for a new VP. He helped bring me up to speed on employee relations issues he had handled and provided some history on the organization. During my first few weeks on the job, I spent much of my time with the Executive Director and Assistant Executive Director. The AED became my mentor and advisor as it related to various issues taking place around the company.

The ED started taking me under his wing. He wanted to teach me the history of the organization, which he co-founded over 30 years prior. It was his baby, and he was proud of it. The ED and I started spending so much time together that

57

Dr. Tana M. Session
Copyright 2020
Working While Black: A Woman's Guide To Stop Being the Best Kept Secret

employees and some of the other executives began calling me his favorite or his "work wife," which did not sit well with the AED, who was destined to take over leadership of the organization once the ED retired.

The organization had not had anyone leading HR in over two years, so he wanted to set me up for success since this was my first time working for a non-profit and within rural New York. Often, he would compliment my intelligence at the weekly executive meetings. At the board meetings, he made certain to add me to the agenda and allowed me to get to know our board members and introduce me to some large financial donors. I soon noticed the AED starting to pull away from me, and our regular meetings became less frequent and were never rescheduled. I heard rumors that the ED was treating me the same way he treated her when she first started, and everyone knew she was his #2 and right-hand person. I tried to dismiss the rumblings, but the more I thought about it, I realized she was excluding me from her team meetings, and we no longer worked out together. I had to admit to myself that something was definitely changing. We both reported to the AED, so I saw her as my peer and a mentor, and I had no desire to take over the organization at any point in my career. I did not have the expertise or education to do so, and I hoped she knew that for herself. But I had no real way of making her feel comfortable unless I started to dim my own light, which I refused to do. I was hired to do a job, and I was good at it.

Dr. Tana M. Session
Copyright 2020
Working While Black: A Woman's Guide To Stop Being the Best Kept Secret

During tours, the ED introduced me to staff members; many had been there almost as long as he had. His brother also worked for the company, and I learned quite a few employees had family members working there. Some had up to three generations within the organization. There was a fair amount of nepotism, but mostly because it was hard to find talent in such a remote area of suburban New York. There were also many affairs between employees and relationships happening around the various campuses, some known and recognized, while others were not widely known.

After spending time with my team, I soon learned none of them had real HR experience. They were placed in HR after departments or positions were eliminated over the years, and none of them had a deep knowledge I was looking for to help me be successful. After a few months in the role, I was able to hire a generalist when I expressed a need for help to the executive team in one of our weekly meetings.

During one of those weekly meetings, the ED dropped 14 personnel files in my lap and asked me to review them to see if we had grounds to terminate each of the employees. A red flag went off in my head, but I agreed to take the files home, go through them, and provide my feedback to the team by the end of the week.

An older Black woman who was on my team became my other advisor. She had been with the organization for over 20 years and knew where all the bones were buried. She warned me not to let the ED or AED use me to do their dirty work. She

59

knew about the personnel files because they had been pulled from HR prior to me starting. Once I accepted the offer, the files were never returned to HR. She also warned me not to get too close to the AED and described her as a snake. I had not seen any signs of that type of behavior and had only found her to be helpful and informative, but I kept her warning in the back of my mind.

There was also a considerable lack of confidentiality in HR and throughout the organization. Somehow, information was consistently being leaked. The HR team knew I had been charged with reviewing the files and coming up with an assessment on whether there were grounds for termination. For some, there were obvious reasons to present the employees with written or final warnings, but there was nothing there for others.

One example was a long-term employee who had won a five-figure workers' compensation case and was still employed with the organization. They were upset he won the case, felt he was not actually injured and wanted to fire him in the event he influenced other employees to do the same thing. I told them that would be deemed retaliation and considerable risk, so they started another campaign against him. They moved him to a new department stating it was better suited to meet his injury's accommodations, and they wrote him up every time he was late to work, left early or took more than an hour for his lunch break. Within a month, there was enough documentation to terminate him, making the ED and AED extremely happy.

60

Once the other employees started receiving their written and final warnings, I started receiving anonymous hate mail. Sometimes it came through an e-mail or a handwritten letter mailed to the HR department or mailed directly to the ED. One letter was even placed on my windshield after dark one evening. I told my fiancé what was happening, and he was concerned for my safety. Honestly, so was I. I realized very quickly I was not in Manhattan anymore and had to recognize this was a different breed of employees I was not used to. I even had to change the way I dressed. The AED suggested I wear leggings and jeans and casual tops to fit in with the way the employees dressed. This was a rural area, and no one wore suits, blazers, slacks or dresses. I had to buy an entirely new wardrobe, so I would not stand out and appear more approachable.

I also learned the ED was a very crass person. He used foul language, and I began to notice he stared at me a lot, to the point it became very uncomfortable at times. During one of our team meetings, the thermostat in his office was not working properly, and a repairman was working on it as we were entering his office to start our regular weekly meeting. As the repairman finished, the ED said to him while looking at me, "I want that thermostat to be so sensitive I can change it from here with the tip of my penis." Everyone laughed. I was horrified. I could barely concentrate during the rest of the meeting. I was just shy of my first anniversary, but I knew I would not make it there much longer. I described the

culture as a combination of the movies "Peyton Place" and "Deliverance." If you are not familiar with these movies, please watch them to have a clear understanding of my experience at this organization.

At one of our monthly team dinners, the ED and AED were discussing a former patient who had passed away. While he was on his deathbed, they said the nurses who cared for him let him feel on their breasts because he loved large breasts. The ED then turned to me and said, "Tana, he would have loved you!" And looked at my breasts, and everyone around the table laughed. I wanted to sink through the floor, and I've never worn that pink turtleneck sweater again!

One morning, the ED invited me to meet him in his office. This was not one of our regular executive team meetings, so I had no idea why he wanted to meet. When I arrived, it was just the two of us. He said he and the AED had met to discuss how they felt I was adapting to the organization. He went on to say they had both been observing me during our weekly meetings and monthly dinners and felt I was not trying to be a part of the team. They felt that I was distant, aloof and judgmental. Perhaps I did not understand their culture or how they operate. He told me to think about if I still felt this was a long-term fit for me, and if not, he would be fine giving me a three or four-month severance package because he just wanted me to be happy.

I immediately asked him if this was performance-related, and he assured me it was not. I met my 90-day goals

and had upskilled the HR department with new staff and improved technology efficiencies. This 'review' was more about personality and fit. I told him I felt a distance between AED and me over the past couple of months and could not understand where it was coming from, but now I know. I asked if the AED was concerned about me wanting her job, and he said he never thought to ask her that question. I assured him I had no interest and was perfectly fine in my VP role.

I said I would think about what he offered and go home and discuss it with my family. I took the rest of that day off and went home. I was shocked and hurt, and my confidence was shaken. I saw this role as a great opportunity on my career trajectory. Friends and family were so happy for me because they knew how hard I worked to get to this level in my career by completing two degrees and three HR certifications in such a short period.

My fiancé said he knew I was not happy there, and I should not work somewhere I do not feel comfortable. He confirmed my suspicions. They did not want a true HR professional; instead, they wanted a puppet to control who would go along with whatever they asked or demanded. That was not my leadership style, and I did not want to compromise my morals and values for a big paycheck.

The other Black executive team member responsible for HR for two years before I was hired called me that evening. Word spread fast! He asked me why I could not just "go along

Dr. Tana M. Session
Copyright 2020
Working While Black: A Woman's Guide To Stop Being the Best Kept Secret

to get along" and said that had been his strategy for over 15 years. He encouraged me to come back, get my paycheck and go home each day and not think about them until the next day. I told him I honestly did not know if I could operate like that, and if so, it would not be for long.

I took the next day off, and when I returned, I asked the ED to meet with me. Meanwhile, I had my fiancé in my office packing my belongings because I decided one way or the other this would be my last day with this organization. I accepted the ED's four months severance offer along with a favorable recommendation, which he agreed to write. I returned to the HR department and said my farewells and wished them all good luck. After ten months there, I could not get out of there fast enough—and I never looked back.

I had no other job lined up, but I had a nice enough financial cushion, and I was confident I would find something back in Manhattan once I put my resume out there. Although I was not looking forward to the five-hour round trip daily commute, I knew I belonged in Manhattan, and I could easily explain my short tenure.

The Third Time Was Not A Charm

I immediately contacted my former boss/mentor from Ernst & Young, who had moved on to yet another company. She once spent some time working for a company in St. Croix, but since then returned to New York when her CEO was found guilty of conducting a Ponzi scheme. She landed a Director of HR role for a small management consulting company and hired me as an HR Operations consultant for three months. She told me she could not promise a full-time position, but I would have a steady income for an additional 90 days while searching for another employment opportunity. This would be our third time working together.

I started consulting on her team, and before my second month ended, she received approval to have me join the team full-time as the HR Operations Lead. I received another increase in my base salary and decided to make this new company my home. It was a great fit, and she and I made a great duo. I was her right-hand person, and we worked well together. This was my first opportunity to work so closely with her at this level in our careers—we were peers. We were able to build a great HR team together and started moving the company forward.

The company was headquartered in London, England, which is where our global HR leader was located. The entire

executive team was all from London and had worked together for years at other companies. The founder was an eccentric gay White man from Belgium who rarely came to the New York office, but everyone was on edge when he did. If he found dust on any furniture or anywhere in the office, he would lose it! His Executive Assistant would have the entire office cleaned the day before his arrival to ensure no one felt his wrath. We later learned he had obsessive-compulsive disorder (OCD) and needed to have everything in a particular order at all times, or he could not function.

My boss and I ensured we had the right technology, infrastructure, policies and procedures to handle a fast-growing company. Because of my commute, I was usually the first in the office around 7:00am each day, which allowed me to speak with the global HR lead in London regularly. She would ask how things were going and constantly told me she heard great things about me from the COO and CEO, and that I have a bright future with the company. I became well-known and well-respected by our teams in New York, Toronto and other parts of Canada, as well as the other global HR team members throughout Europe. The partners all knew my name and sought my advice whenever my boss was not available. I felt I had found my footing there and had no plans to leave anytime soon.

After about a year, I was promoted to Associate Director of HR, one level below my boss. I also married my fiancé (this would be my third husband for those who may have lost

count by now!). Unfortunately, shortly after our wedding, I had emergency back surgery and was on strict bed rest for 10 weeks. I was only allowed to get out of bed for a total of 30 minutes per day, including showers and bathroom breaks. I was confined to a hospital bed but assured my boss that I could successfully work from home. There was no way I could be out of work for 10 weeks, so we made it work through emails, phone calls and video conferencing.

My boss was so anxious with me out of the office for such a long period. My husband hated that I was working so much when I was supposed to be focusing on recovery and officially on sick leave. But I felt obligated to be there for her. I felt I owed it to her. I was ferociously protective and loyal to her throughout my career, and being on bed rest was not going to stop me. Plus, I needed the distraction—I was so bored!

By now, she was starting to experience a lot of pressure from the CEO, COO and some of the senior partners. She was becoming short-tempered with the HR team members, and they looked to me for help since I knew her best. In today's terms, she would be described as becoming "unhinged." I approached her delicately because I felt I owed her that much, and I did not want to see the team turn against her. She admitted she knew her temperament had changed and said she did not like how the executives were treating her. I asked her constantly what more I could do to help her, but there was not much I could do. I told her to let me handle any mistakes the team made to avoid any outbursts from her. Admittedly,

I had never seen her like this in all the years I had known and worked with her. I even called a former coworker from Ernst & Young to see if they had ever seen her behave like this in the workplace, and she assured me it was unusual and said she must be under a lot of stress.

At one point, she had to have surgery for a torn rotator cuff and was supposed to be home for a couple of weeks to recover, but instead, she returned to work within a week. She was still on painkillers and honestly had no business back at work, but I believe she felt her job was in jeopardy. I was covering for her while she was out and was shocked when she returned so quickly. Her temper had not improved, but I blamed it on the fact she was in pain and on medication. I made excuses with the team and COO, whom I had become close to the past year since being promoted. He and the CEO had a long relationship, like my boss and me. Neither was known for liking many people. The COO had his group of favorites, and I was one of them. My goal was to stay on his good side because that meant I stayed on the good side of the CEO as well.

About six months after my boss' surgery, the global HR leader contacted me and told me she was coming to town and wanted to meet with other HR team members and me to discuss my boss. She said this was to remain confidential, and I should not let my boss know about these meetings. She claimed it was an unofficial 360-degree feedback exercise because she had received so many complaints from the CEO,

COO and some other partners about her. I asked her if this was a witch hunt, and she said she hoped that at the conclusion of the meetings, my boss' position with the company would be salvageable.

She arrived in the New York office and spent almost two weeks meeting with the HR team and partners and other stakeholders in our New York, Washington, DC and Toronto offices. At the end of her meetings, she met with my boss and presented her feedback, along with a 30-day notice. She was shocked, as was I. I have no idea what occurred behind that closed door, but obviously, it was not good. My boss was livid. She and I went out to lunch, and she shared some of the main points provided to her. Of course, she wanted to know which HR team members provided feedback besides me, and I told her honestly I did not know. I told her about my feedback input surrounding her outbursts with the HR team members, two of whom went out on stress leave because they could no longer take the pressure from her and the executives. I also mentioned that I had expressed concern when she returned from the surgery too soon, which did not look good because it appeared she was fearful of losing her job. She was still on medication when she returned and appeared irrational at times, and I had to make excuses for her with the team members. I had become a buffer between them and her, which made my job difficult.

We tried to connect the feedback with different people, but by the end of our extended lunch, she realized it did not

matter. She had some goals she agreed to complete before her 30 days were up, and I assured her I would help in any way I could. It felt awkward over those next few weeks. Our global HR lead provided virtual support during the transition period since my boss worked from home most days. The CEO informed us they would start a search for her replacement, but in the meantime, we should continue business as usual. A few weeks after her departure, they had decided on her replacement.

The global HR lead returned to New York and asked me to meet her for breakfast at 7:30am the following day. She knew I was usually in the office by 7:00am, well before anyone else's arrival between 8:00 – 8:30am. We met at a local restaurant, and she told me that she, along with the CEO, COO and the founder wanted to extend me an offer to become the interim Director of HR. She said she spoke to the HR team members and they all thought very highly of me and would support me in this new role. I was shocked and excited, but mostly scared. I saw how they chewed my boss up and spat her out, and I did not want to have that big of a target on my back. I shared as much with my new boss during our breakfast meeting, but she assured me I would have all of the support I needed from her and the executive team.

I was well compensated and comfortable in my role as Associate Director, but the carrot they waved in front of me was enticing. I received a $70,000 pay increase, which took my salary into the mid-$200s, and the COO raised his hand to

be my mentor for the first six months during the transition. What could go wrong? I felt I was set up for success, and after discussing it with my husband, I accepted the role, which was really the epitome of a "battlefield promotion!"

The honeymoon lasted less than a year! During an annual business trip to meet with the global HR team in London, the COO told me he shared with one of my team members that her job was being eliminated. I knew we were cutting some positions and had delivered some news to impacted employees before I left for the trip, but we agreed I would deliver the news to the impacted HR team members when I returned. I was livid and felt undermined. I asked him why he could not wait for my return, and he stated because I was also taking an additional week off for vacation, he did not want to wait for my return and wanted to get the severance payments processed as soon as possible.

A few years prior, we had been purchased by a large financial services firm. We were allowed to operate independently for five years, but by the fourth year, we had to start reporting up to the new CEO and start integrating our systems. Soon, certain key business decisions would have to be approved by the new CEO. Our current CEO and COO wanted to handle a few of these types of matters before change of control happened within the next couple of months. As a result, they wanted to get a lot of overhead and liabilities off the books before the finance integration took place, which was first on the list of action items to be converted to the new owners.

I expressed to the COO I thought his actions were inappropriate and undermined me as the head of HR. He snidely reminded me my position was "interim" and that I ultimately reported to the global HR lead as well as him and the CEO. That told me a lot. I was about six months into this new leadership role, and I constantly asked for feedback from each of them. I also frequently asked if they were still looking externally for a new Director of HR and was repeatedly told no. I discovered upon my return from my European vacation they had lied to me.

When I returned to work, one of my team members told me there had been interviews taking place while I was on vacation. She went on to tell me two offer letters had gone out and been accepted while I was away during those two weeks. I immediately called the global HR lead and asked her if I was being fired, and she said, "No, we are just bringing in extra support for you because this is such a big role now with the acquisition quickly approaching." I believed her because I had no reason not to. I also met with the CEO, COO and the founder, since he was now spending more time in New York as a requirement for the last year of the pre-acquisition. They each assured me they did not hire my replacement but rather specialists in specific HR areas, so I was not spread so thin with such a junior staff. Again, I believed them.

The two women soon joined the team and made me feel very comfortable about where their roles ended and mine began. I remained in the big corner office where my prior boss

used to sit. It felt like business as usual, and the three of us soon found our rhythm. About three months later, one of the new directors resigned. She told me privately she did not like how they hired her without telling me, and she did not like the company's overall culture. She had her own retained search firm and went back to working for herself full-time.

Soon after, the other director resigned as well. She did not like how the CEO and some of the partners talked to her and admitted she didn't like how she and the other director were interviewed and onboarded without my knowledge. She warned me to watch my back and suggested I start looking for another job. I was shocked yet again, but instead of receiving support from the CEO and COO, they kept their distance and rarely came to the HR department. I began to feel like my former boss—the target getting bigger on my back. I continued doing my job to the best of my ability and continued to assure my team all was well, but I honestly was not certain of that myself.

Then one day, the other shoe dropped. While I was on my monthly week-long trip to Toronto to provide HR support to the partners there, I found out one of the senior partners had one of his former HR directors from another company come in to interview for the Director of HR position. This partner co-founded the company with the founder from Belgium, so he carried a lot of weight. By the time I returned from Toronto, she had accepted the offer and was hired as the new HR director.

Once again, I confronted the global HR lead, and she said they were splitting HR in two where I would remain over operations and she would handle recruiting. I knew how much she was paid, and I knew there had to be bigger plans for her role, but I went along with their charade while considering an exit strategy. At the encouragement of the global HR lead, I befriended the new director. I even moved out of the large corner office and moved her into it. She insisted that it was not necessary, but I told her I did not mind at all. I counseled her on various employee relations issues and provided insight into the various partners' different personalities. I became her advisor, but soon I started to feel more like her assistant than her peer.

I noticed my duties started being reduced, and she started questioning my authority on various matters, including being able to work from home every Wednesday to help break up my 20-hour per week commute. She stressed her commute was almost as long as mine, and she had to be in the office every day. I told her I had this arrangement ever since I had back surgery almost two years ago, and it was an medical accommodation. I saw no need to change it now, as I handled all of my duties without interruption.

I complained to the global HR lead since she was supposedly the boss of both of us, and I told her I did not know I had to report to my peer. She told me I was making her job difficult, and I needed to decide if I wanted to remain part of the team or not. I asked her what my options were. She

asked me what I meant by that, and I asked what my options were if I decided I no longer wanted to be a part of this team, as I found it to be a hostile work environment. I felt I was being discriminated against for no apparent reason. I explained that the co-founding partner who hired the new director never liked my former boss or me. They used this as an opportunity to push me out of a role I had been handling for over a year, even after they hired two other people behind my back who quickly resigned.

I also told her I discovered the new director's salary, which was in the low $300Ks, as an unfair payment practice since our roles were presented to me as separate but equal. She could not explain why there was such a big gap except to say she had more years of experience than me, and I had an accelerated career at the company, which they took into account when they gave me the bump in pay a year earlier. I reminded her I held my MBA and multiple HR certifications, which the new director did not have, and I had excellent performance reviews and proven performance in my role. In contrast, the new director was an unknown entity, and the other directors they hired were also paid more and only lasted three months each.

This call took place on a Friday, and we ended the conversation with a promise to continue the discussion early the following week. I reminded her I was out of the office on Monday since I was visiting my son for Mother's Day weekend and would reconnect on that Tuesday. What I did not let anyone

know, except my husband and son, was that I had already started looking for a new job and was regularly interviewing. My husband and I were also considering relocating since we were officially empty nesters.

By now, my son was enrolled in college in Southern California, and through my visits, I fell in love with Los Angeles. During that Mother's Day weekend, I secured an interview for an HR Director role for a private water utility company in an L.A. suburb. At the close of the interview, the recruiter shared the utility company executives specifically wanted a "diverse" candidate for this position. When I probed and asked what they meant by "diverse," the recruiter confirmed I checked off two boxes for them. I was a bit stunned by his remarks but decided to proceed with the interview process anyway.

I had conducted virtual interviews with the retained recruiting firm and the company's leadership team members over the previous few weeks. The final step was to meet them in person, and they were looking to make a decision fast since the current HR Director was retiring at the end of that month. By the time I landed in New York that Monday evening, I had an offer letter in my email along with a relocation package.

On that Tuesday, when I returned to the office, I received a phone call from the global HR leader, and she asked me what type of severance I was looking for if I decided to leave. I told her no less than four months. By the end of that day, I had exit paperwork to review and approve. I took it home to

discuss with my husband and agreed to the terms, requesting a lump sum payout of the four months' severance, along with my unused vacation and end-of-year bonus. They agreed to the terms—and I never returned to the office.

I spoke with a few HR team members I still had a relationship with, some other employees, and two partners I got along with and gave my farewells. They each expressed how they disagreed with the way I had been treated over the past year. I decided not to let anyone know I already had a new job. Based on my start date, we only had four weeks to pack and relocate cross country, and I could not wait to put this experience behind me and start over in Los Angeles.

The Republic of California

My husband, the family dog, Oreo, and I landed in Los Angeles to start our new life four weeks after I walked away from my New York job. The sky was pure blue, the sun was shining, and the palm trees were swaying in a soft breeze. We arrived in Pasadena a full day before our moving truck and vehicles did. After touring our new apartment complex, we checked into our hotel and waited for our furniture and cars to arrive the following afternoon. I had one week to settle in before I started my new HR Director job at the private water utility company. In advance of my official start date, I requested to have a luncheon with my new HR team since I had not met any of them during the interview process. I did not even have the opportunity to tour the office while I was there for my interview a few weeks prior. The CEO arranged a luncheon on my third day in Los Angeles, and I was able to spend two hours getting to know the names and roles of my new direct reports and answer their questions about me and my experience. It was a warm welcome, and I looked forward to starting my first week in a few days.

I met with the CEO and established my 90-day goals, a practice I started when I landed my first HR manager job seven

years prior. It gave me a solid North Star, so I knew what to focus on, how my success would be measured, and what would be expected of my team and me. I aligned myself with one of my peers, the Senior Vice President of Operations, a White woman who spent her entire 30-year career with the company. I learned she and I had a lot in common. We both only had one child, a son, and we both had stay-at-home husbands who were entrepreneurs, making us the primary breadwinners in our families. I noticed how healthy she ate, and she shared with me that she had lost over 100 pounds by using a fitness app and even offered to introduce her Nordstrom's stylist to me since we were the "most stylish" women in the company, as she put it. We enjoyed our meetings and getting to know each other. She even admitted to me once that she especially appreciated our time together because she did not have many friends in the company, which she attributed to her senior level in the company.

We met weekly so I could run ideas by her before presenting them to the CEO, and she taught me more about some of my key stakeholders, two of whom reported to her. She was responsible for the most significant part of the business, held a lot of power and had considerable influence over the CEO. He had only been with the company for 11 years and started as the CFO until the former CEO retired and the board nominated him to the CEO role. He would constantly make remarks in our executive meetings that this may be the month the board voted him out of his job. He said it in jest,

but it never made me feel comfortable, and I began to wonder what I stepped into at this company.

I quickly learned working for a utility company appeared to be similar to working for the City of New York or a federal agency. I was used to a quick decision-making process, but here decisions were slower, measured and deliberate. During my interview, the common theme from the CEO, CFO, and other SVPs was the need for change and innovation in HR. I was told that this desire for change was the determining factor in extending the offer to me as opposed to the other final candidate, a White man from Texas.

During my three and six-month reviews with the CEO, he confirmed I exceeded my 90-day goal plans and made significant progress for the HR department. I also attended the quarterly board meetings and received high ratings and praise from the committee members. It was during one of these quarterly meetings when I learned the board members were the ones who requested a "diverse" candidate for the HR director role.

The company had experienced a complaint filed with the EEOC regarding a lack of diversity in managerial positions. After working there for a few months, visiting the various locations up and down the California coast, and meeting several employees face-to-face, I could attest that there was a lack of diversity. This especially rang true amongst managerial roles, and I soon started providing the metrics in my board reports to prove it. I was determined to help fix that by

looking at internal candidates for promotions before looking externally. Little did I know, I was fighting an uphill battle.

Each internal candidate had some history that did not align with the SVP of Operations' view of them as a viable candidate. She and her direct reports, two White male directors, had been employed with the company for over 100 years combined. They had a long memory about every negative mark on almost every current employee. I stressed if the incident occurred more than six months ago, and if they were still employed and receiving favorable reviews and raises, then what happened in the past should no longer be held against them. I stressed this same opinion to the CEO and the board behind closed doors, which I later learned put me officially in the operations leadership team's crosshairs.

My weekly meetings with the SVP started getting canceled and not rescheduled. Then our monthly luncheons experienced the same fate. I soon learned her passive-aggressive behavior was not out of character. She had isolated many others before me in the same way, including those who were once considered friends. Additionally, during my first year, I was invited to be a part of all interview panels throughout the company. Shortly after I started leaning into my position and authority as the head of HR and implementing some cultural changes, the operations team was told by the SVP they no longer had to include me in their interview panels.

When I discussed this with the CEO, he said he was reluctant to tell the SVP how to run her department because

she and her directors knew who the department's best fit would be. I had to ask him if I was still the head of HR for the entire company, and he assured me I was but asked me to let this battle go so I can win the war. He said her two directors were probably going to retire in the next two to four years, and I should just focus on the other areas of the company where I was excelling. I told him I did not know how that would work; being isolated from the company's largest section's recruiting process was a slippery slope, and I was correct. Soon, the operations directors started usurping me on employee relations matters by having the internal general counsel handle them. This was a White man who reported to me, but he did not want to get on the SVP or her directors' bad side, so he went along with their plans.

When I found out about this, I confronted the general counsel, and he tried to explain it in a way that was of little importance. I assured him working around me was significant and undermined my position as the HR lead for the entire company. He told me I upset the operations leaders when I insisted on handling their recruiting. I had actually shared with the board about the difficulty in getting diverse internal candidates promoted in their division. I then met with the CEO and shared the conversation I had with the general counsel with him, and I asked for his guidance. After asking me how I became so "confident," he suggested focusing on performance management, employee training and recruiting for the other departments. He said things would get better for everyone

82

once the two White male operations directors retired, which he anticipated would be less than five years.

The final straw came when one of those directors started harassing me through emails. He was upset that we had digitized all employee files, dating back to the 1970s, to increase employee and applicant efficiency. Our new HRIS system allowed employees to change their personal information and payroll tax deductions without anyone in HR having to touch paperwork. I had notified all managers in an email prior to implementing the new system. Once the systems were functioning, we notified and trained employees.

One day this director came to the HR department to pull an employee's file to review and was surprised the file closet was empty. He barged into my office to confront me, and I told him I did not appreciate the tone of his emails to me or that he copied his boss and CEO on them. I asked him why that was necessary, and he said his boss, the SVP, told him to track all his work. We went back and forth, and when he asked me who gave me the authority to get rid of the employee files, I told him I had the authority of the CEO and the board. If he did not like the direction we were going in by innovating the HR department, he could take it up with them.

After our meeting, I sent an email to the CEO. I informed him that the director's behavior toward me was hostile and unacceptable, and I expected him to do something about it. He assured me he would and asked that I not communicate with the director until he had a chance to investigate. By now,

I was convinced this was no longer the company for me. I lost interest in going to work and started coming in late, leaving early or calling out sick over the next few weeks. This was not my normal behavior because I always believed in giving more than I was getting from a company. My husband and son told me to start looking for another job, but I did not feel that was what I wanted to do. I started thinking about creating *my own* HR consulting company, which I had already incorporated in New York when I resigned from my last company.

I contacted an employment attorney to find out if I had any grounds to sue the company. After hearing my story and reading through various emails and my performance reviews, my attorney, a Black woman, felt confident I could sue under the grounds of hiring me under false pretenses. I also told her I was under an extreme amount of stress, and she recommended me to a workers' compensation doctor. By now, I had already started taking some of my belongings home from work but did it so subtly, no one noticed. I left artwork and other obvious items, with plans to collect them at some point in the near future. After meeting with the doctor, he immediately placed me on FMLA leave for six weeks. My team was in shock, but they completely understood my decision because they had a front-row seat to witness what was happening to me.

Shortly after I was placed on FMLA leave, my attorney sent a letter indicating we were filing an official complaint and were suing the company. We requested a year's salary

Dr. Tana M. Session
Copyright 2020
Working While Black: A Woman's Guide To Stop Being the Best Kept Secret

along with the bonus I was entitled to at the end of that year. Additionally, my attorney insisted that for this payout, my salary be increased to match what the other directors were paid since I was the lowest-paid director. I found this salary discrepancy out early during my employment. I learned the general counsel who reported to me had a higher salary than mine, as well as the prior HR director.

When I asked the CEO about the difference in pay, I reminded him I took a $30k pay cut when I accepted the position. He mentioned I received a relocation package, which had not been included with the original salary. I told him that should not have mattered since it was only paid during my first year of employment. I had to stay with the company for three years to avoid having to pay any portion of it back to the company.

Well, my attorney used that same argument, and it worked. They did not want to go to trial and instead spent 12 hours in mediation. My attorney, husband and I were in one room...and the CEO, general counsel and their two attorneys were in another room. We ended up having breakfast, lunch and dinner in that room that day. During the mediation, they decided to minimize my online college degrees and the time I spent running my own company. They tried to use those against me to validate why my salary was lower as the only Black female director in the company's history. As I mentioned in an earlier story, I was ahead of the curve obtaining my online degrees in the early 2000s, and not all employers had

an appreciation for them the way they do now. My attorney countered their argument by stating that they should not have hired me and relocated me and my family cross country for a $30k pay cut if this was such a concern for them. Boom! By 9:00pm that evening, we reached a confidential settlement I could live with, and I was able to move on and officially launch my own consulting company.

+++++

If you are with me this far, you might be wondering if my career challenges had anything to do with ME or everything to do with EVERYONE ELSE. The answer is... it is probably a little of both. Black women know the deck is stacked against them in many ways, and most of us will "go along to get along." That is just not who I am. So, did my attitude and body language unconsciously convey my dissatisfaction? Probably. But I refused to be my own *best kept secret*, and if that meant changing jobs – or starting my own business – to try to find the ideal place for me and my talents, so be it! In speaking with other Black women who started their own businesses, I learned they experienced many of the same issues in corporate America that I did. So my story is not unique. Like me, they decided to create their own path and definition of success by being their own boss!

After all these years, I have concluded, White women, in particular, have been significantly intimidated by me as I rose to the executive level in my career. They have been intimidated

by my confidence. By my intelligence. By my style. By my light and how bright I allowed to let it shine. By the power they saw in me that I sometimes did not see in myself. Instead of being an ally or a supporter, they choose to make me so uncomfortable that I would opt to leave so I could no longer dim their light (constructive termination at its best!) Or make me an offer to leave that I could not refuse. Either way, in the end, all I did was WIN...and I haven't looked back!! As Nelson Mandela stated, "I never lose. I either learn or WIN!" FACTS!

My Journey To "Stop Being the Best Kept Secret®"

At the start of this book, I mentioned I would share the five (5) proven strategies to Stop Being the Best Kept Secret®. In the following section, I will describe to you how these strategies, **Own Your Power, Own Your Truth, Own Your Healing, Own Your Worth**, when applied and practiced daily, will not only elevate your career but they help you own who you are and take up space when you show up in the world each day.

Own Your Power

From the outside looking in, you would think I should have felt empowered and authentic, but there have been more times than not when I've felt like a fraud. I have suffered from imposter syndrome for many reasons, the first of which was my humble background and because I did not obtain my degrees the traditional way.

I was born into the foster care system of New York City and remained there until I was reunited with my family at 3 ½ years old. However, I spent most of my life in fear of rejection because I had experienced it so early in my life. This fear showed up in how I reacted in the workplace and

relationships. If I felt I was being rejected for any reason, real or perceived, I responded negatively. This behavior caused me to sabotage relationships, friendships and in some cases, my career. I suffered from a lack of fully understanding the power I had inside me to reach my full level of empowerment and self-confidence. I had to learn coping tools to address those feelings and behaviors when they crept up in my life.

There were five areas I needed to face to fully own my power. I had to learn how to forgive myself, forgive others, not compare my journey with others, give myself permission to succeed and learn how to use my adversities as fuel for my success...and not excuses for remaining comfortable and stagnant. This was a paradigm shift for me. I never shared my humble background with anyone I ever worked with, including my boss/mentor from Ernst & Young. I let people assume what they wanted to about my background based on how I showed up in the workplace. It was a false sense of power built on quicksand.

Once I healed from my past and shared my story for the first time after starting my own consulting company, I truly leaned into all of my power and who I was authentically and honestly for the first time in my career. It was freeing, and I wish I had done it sooner. In my last position with the utility company, when the CEO asked me how I became so "confident," I told him it took years to gain the self-assurance to stand in my knowledge and experience as the head of HR for multiple companies. That was a very safe answer at the

time. If someone were to ask me that question now, I would be willing to share my entire "truth." I had to do a lot of self-discovery and self-healing work. Through that work, I have learned that I am more than enough, and I firmly stand in my truth every day!

Own Your Truth

The truth does not hurt; it heals. As Jay Z said on his album 4:44, "You can't heal what you don't reveal." I've learned that firsthand. When you honestly learn to speak your own truth, you do not have to worry about someone else telling your story, which means they will not have power over you. I decided I would no longer hide behind the mask I used to put on for the world to see. Once I learned how to live with authenticity, there was no going back. I also learned living in my truth had a direct impact on my net worth!

Your truth is your armor against the world. It can be scary, but it is also powerful! When you no longer have to hide, pretend or live a lie, you are FREE. Your heart space opens up, and good, positive energy replaces all of the negativity. I have learned if you want your freedom, you have to fight for it every single day!

Own Your Healing

We will repeat what we do not repair. Often, a lot of what we have to heal from is not even our fault; but it is our

Dr. Tana M. Session
Copyright 2020
Working While Black: A Woman's Guide To Stop Being the Best Kept Secret

PROBLEM. What do I mean by that? Well, think back to how you were raised. What types of things were said, or done to you, that you never addressed? Those will show up as historical pains that run so deep; they stay with you until adulthood. The stories we tell ourselves share beliefs about who we are and how we show up. I had to learn how to rewrite my story through my healing.

On a personal level, I had to heal from rejection, feeling unwanted and being teased as a young girl growing up with no parents around. Whenever I was placed in a situation that reminded me of those scars, it was like having the hurt happen all over again.

On a professional level, I also had to heal from being harassed in the workplace, not being paid fairly or equitably, other people's skepticism about my abilities and having people stab me in the back. I could have continued to carry these negative experiences throughout my career and even into my business. Yet, I learned they no longer served me and were only holding me back from the success and blessings that were waiting for me on the other side of adversity.

Until I knew better, I did not know how to cope with these painful events, and more importantly, I did not know how to HEAL from those painful memories. It took time, work and honest conversations with myself. I had to look myself in the mirror and learn to love the person looking back at me, flaws and all!

Own Your Worth

Once you cross over and embrace how to own your power, nothing and no one will stop you! You are truly worth it!! What is "it?" Whatever you desire and want for yourself. In most cases, it will require a mind shift, which can take some time. Admittedly, we often wear the cloak of others' opinions and narratives about us, dating as far back as our childhood. The bottom line is simply this: these narratives can get inside your HEAD and HEART, resulting in how you move through life and ultimately place a value—or worth—on yourself in your career, business, relationships and life in general! I finally learned how to remove my mask and show up as "Tana," embracing all her scars and wounds with no apologies. I can assure you it was worth it for me, and it will be for you as well.

Own Your Destiny

"Your future is so bright; I can see it from here"~ Oprah.

Over the years, I have learned to remove all self-imposed limits on what I think I can achieve. Although I have accomplished much throughout my corporate career and entrepreneurial endeavors, I am always considering my next milestone. I do not want to become comfortable or complacent. Ever since I was a little girl, I always felt I was destined for something bigger and better than my current situation. I have used that feeling as my North Star whenever I made a pivot in my career or relationships. I refuse to settle, and I set healthy boundaries in my personal and professional lives.

My hope for everyone reading this is that you will walk away with this same level of conviction. Learn from all the adversities I faced in my youth and throughout my corporate career. Remember, no situation is permanent unless you decide to make it so. There is a saying that goes something like this, "When you're going through hell, don't stay there. Keep moving! Who wants to stay in hell?" That is my personal motto, and I welcome you to embrace it in your own life.

Dr. Tana M. Session
Copyright 2020
Working While Black: A Woman's Guide To Stop Being the Best Kept Secret

Working While Black:
The Black Woman's Plight in Business

Is there any wonder why female-owned businesses grew by 58% between 2007 to 2018, and for Black women, the number nearly tripled, increasing by 164%? Dissatisfaction with corporate America has resulted in the "fight or flight" of Black women in the workplace. Black women always have to be mindful of how we show up. This is how we were trained. But that time has finally passed. Our hair and nails, what we wear, how we speak and what we talk about are changing... and we are reclaiming our power. We are overturning the traditions that no longer serve us.

Black women have to show people who we <u>AREN'T</u> before we can show them who we <u>ARE</u>. And White fragility is REAL. There have been many books and articles written about the various issues Black women face in the workplace. Some people are familiar with some of these terms and ideologies, and some are not. To help level the playing field, I have listed the most popular terms below and provided definitions and examples as well as anecdotes on how these issues show up in the workplace. I can honestly say I have experienced each of them, sometimes in multitude, at each place of business I have ever worked for throughout my career. I am sure many of you reading this book can echo these same sentiments through your own experiences. And let me add that some of these terms are not isolated to Black women in the workplace. Some can be applied to ALL women...and many men, too!

Dr. Tana M. Session
Copyright 2020
Working While Black: A Woman's Guide To Stop Being the Best Kept Secret

Imposter Syndrome

Earlier I mentioned suffering from imposter syndrome during certain points in my career. Over the past few years, I have "diagnosed" this syndrome in numerous clients and shared examples of it in many of my keynote speeches. What I quickly realized was there was a lack of understanding of what imposter syndrome is. Before defining it, I want to stress that everyone suffers from it at some point in their personal or professional lives, but it is most prevalent in people of color and women. By definition, imposter syndrome is *"the persistent inability to believe that one's success is deserved or has been legitimately achieved as a result of one's own efforts or skills"* ~ Oxford.

According to EmpoweringAmbitiousWomen.com, here are the most popular signs of imposter syndrome:

- You are a perfectionist.
- You are a high achiever.
- You prefer to do things yourself so that you can hide the struggle.
- You feel nothing you do is ever good enough.
- You work longer and harder than you need to – and longer and harder than anyone else.
- You over-prepare for everything.

Dr. Tana M. Session
Copyright 2020
Working While Black: A Woman's Guide To Stop Being the Best Kept Secret

- You need to be Superwoman (man).
- You don't believe any praise you're given.
- No matter how good your work is, you still think someone will notice it's not good enough.

People who suffer from this syndrome often feel anxious and are uncomfortable with new challenges. They fear those around them will discover their incompetence, so you work extra hard to cover it up. It is exhausting, and at the end of the day, most of these issues are only in your imagination, and no one else cares. You are more worried about others and what they think of you than they are worried about you. Save your energy and focus on what really matters, and more importantly, run your own race! Remember, perfection is not reality, and everyone makes mistakes.

My lack of a college degree early in my career, my humble beginnings in the foster care system and having drug addicted and alcoholic parents were the primary sources of my imposter syndrome. Additionally, the hostile experience at the end of my term as the interim HR director at my last company in New York shook my confidence to the core! Over time, I began to feel a lack of genuine trust in my ability to run the HR department, even though I had proven I was capable of the role for over a year. Once I learned to own my power and my truth, I got over these symptoms almost instantly, and you can, too.

But I would be remiss if I don't mention the fact that imposter syndrome would be less of a problem for marginalized

groups if the systems were not designed to foster those feelings. Ultimately, organizations need to revisit how their policies, procedures and infrastructure are designed to make women and people of color feel "less than" or "other," and remove all barriers to entry or pathways to success. There is an accountability factor involved here. That's when you will truly be able to minimize - and hopefully eliminate - individuals feeling inadequate in those spaces.

Dr. Tana M. Session
Copyright 2020
Working While Black: A Woman's Guide To Stop Being the Best Kept Secret

Microaggressions

I cannot talk about Black women in business scenarios without discussing microaggressions. These are little slights or comments made in passing or in jest, primarily by White people, that leave emotional scars we tend to cover up, never discuss and often think we must be *"too sensitive," "crazy"* or *"they didn't mean that."* In most cases, we are not being overly sensitive. Consistently mistaking one Black woman for another is a form of microaggression. This tends to occur when only a few Black women work in the same office or on the same team and are called by each other's names by their White counterparts. It follows the negative adage that we (Black people) all look alike. This is a hurtful slight and disrespectful when White people do not make an effort to remember each coworker's name. It makes us feel invisible. It makes us feel as if we are not important enough to remember our name. This is a historical scar that dates back to slavery when some slave owners did not give names to their slaves. The Blacks who did not have names were only called "boy" or "girl." And please also learn how to pronounce our beautifully unique and ethnic names correctly! And NO...you can't abbreviate our name or call us by another name to make it easier for you, unless we give you permission to do so!

Dr. Tana M. Session
Copyright 2020
Working While Black: A Woman's Guide To Stop Being the Best Kept Secret

Another example of an all too frequent and common microaggression is telling a Black woman she is "articulate" – which is NOT a compliment. To take it even further, telling any person of color they are articulate or "speak English well" is not a compliment either. It assumes we are not from this country, or we are going against the stereotype a White person may have about who we are and how we are supposed to show up. It is insulting!

I was on a plane one day flying first class from a speaking engagement at the University of Minnesota. Not only did I get a questionable look from the White female flight attendant, but the White gentleman sitting next to me looked confused as well. After getting settled in for the flight and ordering my adult beverage, I could tell my seatmate wanted to start a conversation. He asked if I was from Minnesota, and I told him I was from Los Angeles by way of New York and was returning home from a speaking engagement at the university. He then asked what I did for a living. After explaining I was an international speaker, HR consultant, bestselling author and media contributor, he looked at me and said he was thoroughly impressed and proceeded to tell me I was so articulate. I immediately responded by saying, "Thanks. So are you!" I then put my headphones on so I did not have to speak to him for the remainder of the flight! Again...it's Not a compliment!

Additionally, I am almost positive Black women are the only women in the workplace who have to repeatedly ask coworkers not to touch their hair. Our hair comes in many

textures and colors, and Black women are known for changing their hairstyles multiple times in any given year. Our hair is our canvas and one of the ways we outwardly express who we are. We do not mind the compliments and maybe even answering sincere, curious questions, but *please do not touch our hair.* This is a deep historical scar for Black women and goes back to slavery days when our ancestors did not have the right to say who could or could not touch their bodies. Our first reaction is to protect our personal space, resulting in someone's hand being slapped away as a reflex. Do not take it personally; just don't touch our hair. And please do not even ask for permission to touch our hair. It is not appropriate under any circumstances.

I was on vacation at a resort in Mexico with my husband, and we were enjoying drinks at the swim-up pool. Soon two other White couples joined us, and we began small talk. I could tell one of the men had started drinking before they arrived at the swim-up pool, but he was entertaining, nonetheless. After about 15 minutes of harmless conversation, he hops off his stool, passes his wife, who was sitting next to me, and out of the corner of my eye, I saw his arm raise and start to reach out for the back of my head. My reflexes kicked in, and I swatted his hand away from my head. My husband turned around to see what was happening. His wife looked shocked, and he nervously laughed and said he had never touched a bald woman's head before. I assured him that today would not be the day he would make that a reality and asked him

not to touch my head. He persisted in asking for permission, which I told him was not going to happen. My husband and I left the pool because we knew he was intoxicated, and I knew my husband was losing his patience. Permission not granted!

According to a survey conducted by Ella Bell Smith and Stella Nkomo, 90% of Black women admitted to having conflicts with their White female counterparts. However, only 4% of White women felt they had experienced conflict with their Black female counterparts. I assure you microaggressions are a significant source of those reported conflicts by those Black women.

Angry Black Woman Syndrome

I will be honest with you, under-employed, marginalized and underrepresented Black women have a LOT for which to be angry. Still, we also know how to contain that anger and we do so on a regular basis. We also have unique facial expressions and body language. Whether it is a side-eye, eye-rolling, twisting our lips, sucking our teeth, exhaling loudly, holding our head to one side, rolling our necks, or frowning our brows—please note these do not equate to a Black woman being angry. We are also known to place our hands on our hips, put a hand out to stop a conversation or simply talk with our hands. We are expressive women, and these are **all** acceptable forms of communicating in our culture. Not every expression or tone comes from anger. Black women want to speak confidently, with authority and assertively without others feeling intimidated or thinking we are attacking them.

When a White woman expresses herself in this way, rarely is it perceived in the same manner. Now admittedly, most women who appear overly confident or assertive are often called a "ball-buster" or a "bitch" or described as "PMSing." Yet when a Black woman speaks in this way, there is an added layer of unacceptability. This is one example of how the intersectionality of being Black AND female crosses paths.

Dr. Tana M. Session
Copyright 2020
Working While Black: A Woman's Guide To Stop Being the Best Kept Secret

Intersectionality

Being Black in business is a challenge in itself when trying to navigate success, but when you add being a Black *female* in business, the stakes are higher. Black women are less likely to have mentors and sponsors who can advocate on their behalf. There are far fewer Black women in management and leadership roles than there are White women. On average, Black women make $.67 for every dollar a White man makes, compared to White women, who make $.79. Asian women make $.97. and Latina women make the least, at a low $.58 for every dollar a White man makes. As of April 2021, there are only 41 female CEOs for the Fortune 500 companies. And with the retirement of Ken Frasier at Merck in June 2021, there will only be a total of four (4) Black CEOs remaining on the list, and of them two (2) are Black women (Walgreens and TIAA). Fortunately, we are seeing an increase in more Black women joining corporate boards.

According to Harvard Business Review, although Black women represent 12.7% of the U.S. population, we only account for 1.3% of senior management roles at Fortune 500 organizations and 2.2% of Fortune 500 boards. However, Black women are the most educated group of people entering the workforce today. So why is there such a lack of representation

in the higher ranks in organizations? This begins early in their careers, mainly because of the pay gap and lack of mentors and sponsors. Additionally, Black women are physically visible because they stand out as the "only one" or one of a few, but they are often theoretically invisible. Therefore, they are overlooked, forgotten or disregarded for promotions, causing them to lag behind their White and Asian counterparts.

Several companies promote their diversity and inclusion initiatives, but there has been a lack of metrics proving these programs are effective. More importantly, any company can check its diversity box since it is a quantifiable and visual component. For example, hired a Black female? Check and check! However, what is less measurable and noticeable is the feeling of inclusion and belonging. This is where the new focus needs to be to ensure those Black women being hired also feel included, that they belong and that they are not the "only one" in management roles or with a seat at the table.

Even most affinity or employee resource groups (ERG) focused on women's workplace issues are not addressing Black women's issues. The issues that stakeholders are more focused on are general "women's" issues or work/life balance issues, leaving the "Black" issues discussed in the affinity group that focuses on all Black employee issues. This is another gap that needs to be addressed.

Being the "only one" can feel like a burden for Black women. I know because I have been there more than once

during my career. The feeling is that you represent the entire community of everyone who looks like you. However, Black women are not martyrs or monoliths, and do not represent all Black people or all Black women in the workplace. Each of our experiences is different and unique. And for those employees who look like you, they expect so much more from you based on your level of influence and the fact that you "made it."

Little do they know, Black women face their own struggles, often alone with no one they can trust or talk to, or be their true authentic self with daily except when they go home at the end of each day. We cannot have emotional outbursts or cry at work for fear of our reputation being negatively impacted. But our White counterparts can with no repercussions. Black women also do not want to be the one who messes it up for the next Black woman or man. This makes them extremely cautious and intentional. We try not to rock the boat too much or show favoritism or nepotism towards other Black employees. These observations certainly do not apply to all Black women because I know some who make the earth shake from their corner office with no apologies to anyone, and I love watching their #Blackgirlmagic.

But all Black women are not there yet. After all, I still have Black female clients who ask me whether it is appropriate for them to wear their natural hair to work, so we still have a long way to go. Several states have

now adopted the CROWN Act, which is a Human Rights law protecting against natural hair discrimination in hiring and promotion practices and in the school system. Yes, there are now laws protecting people of color from discrimination against the way their hair naturally grows. Unreal!

Dr. Tana M. Session
Copyright 2020
Working While Black: A Woman's Guide To Stop Being the Best Kept Secret

Code-switching

Black people, in general, are masters at code-switching in the workplace. It is common practice to use less slang, enunciate our words and use proper verb tense when communicating with non-Blacks in professional settings. Admittedly, there is a bit of code-switching for everyone to a degree, regardless of race or gender, and depending on the audience. In some instances, this represents how emotional intelligence kicks in and is necessary in some professional settings. Earlier I listed examples of the ways Black women express themselves with facial expressions and body language. Part of our code-switching is to tone those natural behaviors down based on who we are communicating with. We can appear one way in mixed company at a meeting, but catch us behind closed doors on the phone with friends or family, or at lunch with our Black friends, and you will see the other side - our true and beautiful authentic side - come through. Again, this is an exhausting but necessary practice until the workplace has shifted in a way truly embraces Black people for their true authentic selves without apology. Some organizations get it... but from my experience, those are few and far in between.

There are no etiquette books or classes we take to teach us this method of becoming professional chameleons; it is

Dr. Tana M. Session
Copyright 2020
Working While Black: A Woman's Guide To Stop Being the Best Kept Secret

just a learned practice once we enter the workforce, or we learned from our parents, grandparents, other guardians or older siblings' experiences. We observe our surroundings and adjust accordingly, primarily because we know from childhood the professional systems were not designed for us to succeed and do not favor us in any way. I repeatedly tried to work the system, how I saw my White counterparts do it and succeed, and it failed me every single time!

Many Black people are told from school age that we had to "work twice as hard to get half as much," and although this may not be the case for every Black woman or man in the workplace, it is still quite relevant and helpful to keep in mind.

I remember when I went to see Michelle Obama in Los Angeles during her book tour. The First Lady shared with the audience the type of feedback she received from her staff during her early days in the White House about how she was being perceived by the public whenever she made public speeches or gave interviews. Apparently, she was coming across as too aggressive, and her facial expressions made her appear angry, irritated and unapproachable. Yes, even Michelle Obama had to learn how to code-switch to help make others feel comfortable around her. She said she had to practice smiling more when she spoke and softening her facial expressions and tone.

Black women have to be intentional in developing professional personalities that debunk negative stereotypes.

We have to be friendly and soft, but not sexy. We cannot be bossy or loud, and definitely cannot display any stereotypical "ghetto" behaviors. We also have to attempt to blend in, which requires double-checking our attitude, tone, diction, appearance, style of dress and facial and body expressions daily. Some would probably describe this as playing a smaller version of ourselves until we can go home and take the mask off. In a lot of ways, code-switching is purely a survival methodology. But it is exhausting!

One of the most significant undertakings I took as part of my own code-switching was learning how to play golf and eat sushi with chopsticks. I had a CEO who loved to participate in an annual golfing tournament and would invite his senior staff, all men. I was the only female on the senior staff and always found an excuse not to go because I didn't know how to golf. I had never even been on a golf course. Although he assured me I did not need to know how to golf to attend the outings, I still didn't want to be "that" person on the team who looked like a fool. Can you sense how the imposter syndrome kicked in? Eventually, my husband and I took putting lessons so we could learn the basics and at least hit the ball properly. My husband even purchased clubs, golf balls and a net so we could practice at home. I am not a golfing pro, but now I am comfortable on the course and just focus on having fun and networking.

My former boss from Ernst & Young used to take the team out for sushi luncheons a couple of times each month.

Not only did I have to learn how to like sushi, but I always had to ask for a fork to eat my lunch while everyone else used chopsticks. The waitress would secretly bring it to me wrapped in a napkin as if I was asking for an extra seatbelt on an airplane! Fortunately, at the time, I had a close friend who was Asian American, and I asked her if she would teach me how to use chopsticks. We met in the cafeteria at the end of the day for about a week while she showed me how to eat various foods with chopsticks and taught me chopstick etiquette, which I then taught to my husband and son. Since then, none of us have eaten sushi with a fork ever again!

Golf and sushi are small and simple, but I share my stories as examples of the steps I took to adapt and fit in and make myself feel comfortable in my surroundings with people who did not look like me. Growing up, I was not exposed to golf or sushi, so I had no point of reference when I was faced with both in my professional life. But I have to wonder how many of my White coworkers would make the same effort to adapt and fit into my world. Some would probably never even come to the neighborhoods I had lived in before I was able to move to the suburbs!

The good thing is once people get to know you on a personal and human level, some of the necessary code-switching can be minimized over time. This will require Black women to look for similarities and build authentic relationships early on in their careers so they can show up

111

as their whole true selves and perform at their highest level. This has its share of risks, but I feel confident the rewards will outweigh them.

At the end of the day, we need honest and authentic allies: all ethnicities, all races, all nationalities and both men and women!

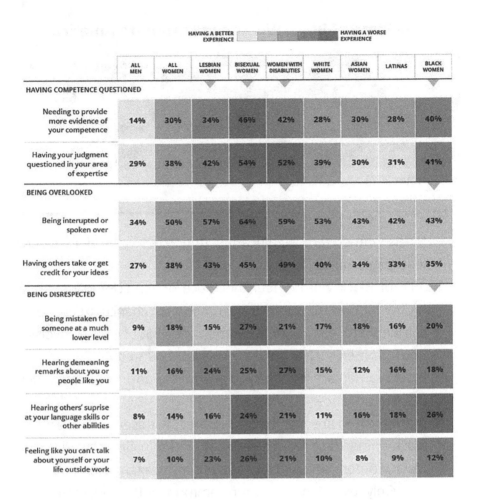

	ALL MEN	ALL WOMEN	LESBIAN WOMEN	BISEXUAL WOMEN	WOMEN WITH DISABILITIES	WHITE WOMEN	ASIAN WOMEN	LATINAS	BLACK WOMEN
HAVING COMPETENCE QUESTIONED									
Needing to provide more evidence of your competence	14%	30%	34%	46%	42%	28%	30%	28%	40%
Having your judgment questioned in your area of expertise	29%	38%	42%	54%	52%	39%	30%	31%	41%
BEING OVERLOOKED									
Being interrupted or spoken over	34%	50%	57%	64%	59%	53%	43%	42%	43%
Having others take or get credit for your ideas	27%	38%	43%	45%	49%	40%	34%	33%	35%
BEING DISRESPECTED									
Being mistaken for someone at a much lower level	9%	18%	15%	27%	21%	17%	18%	16%	20%
Hearing demeaning remarks about you or people like you	11%	16%	24%	25%	27%	15%	12%	16%	18%
Hearing others' suprise at your language skills or other abilities	8%	14%	16%	24%	21%	11%	16%	18%	26%
Feeling like you can't talk about yourself or your life outside work	7%	10%	23%	26%	21%	10%	8%	9%	12%

Top legend: HAVING A BETTER EXPERIENCE — HAVING A WORSE EXPERIENCE

Experiences of Black Women In Corporate America

Lean in Women in the Workplace Report - McKinsey & Company 2019

The State of Black Women in Corporate America

BLACK WOMEN	COMPARED TO WHITE WOMEN	COMPARED TO BLACK MEN	COMPARED TO WHITE MEN
Sense of opportunity at their organization	-30%	-47%	-63%
Have recieved recognition in the past month	-65%	-64%	-74%
Feel like they belong	-46%	-34%	-48%

*OC Tanner 2021

- Black women are significantly underrepresented in senior leadership roles.
- 49% of Black women feel their race or ethnicity will make it harder for them to get a raise, promotion or chance to get ahead, compared to just 3% White women and 11% of women overall.
- Black women's successes are often discounted.
- Black women are less likely to get the support and access they need to advance.
- Black women are less likely to interact with senior leaders.
- Black women face more day-to-day discrimination at work.
- Black women face a wider range of microaggressions.
- The "Only" experience is far too common for Black women.
- Many White employees are not stepping up as allies to Black women.
- Black women remain highly ambitious in spite of the obstacles they face.
- Black women want to lead and are motivated to improve their workplaces.

Lean In 2020

The "Problem" Woman of Color in the Workplace

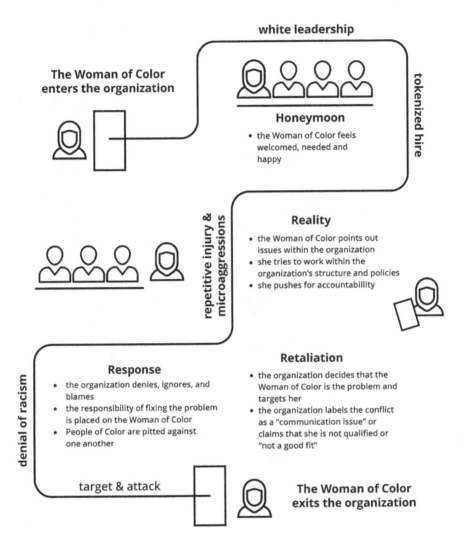

white leadership

The Woman of Color enters the organization

tokenized hire

Honeymoon
- the Woman of Color feels welcomed, needed and happy

repetitive injury & microaggressions

Reality
- the Woman of Color points out issues within the organization
- she tries to work within the organization's structure and policies
- she pushes for accountabillity

Retaliation
- the organization decides that the Woman of Color is the problem and targets her
- the organization labels the conflict as a "communication issue" or claims that she is not qualified or "not a good fit"

denial of racism

Response
- the organization denies, ignores, and blames
- the responsibility of fixing the problem is placed on the Woman of Color
- People of Color are pitted against one another

target & attack

The Woman of Color exits the organization

THE INTERVIEWS

Swati Mandela: Entrepreneur | Humanitarian

Swati Mandela (Zamaswazi Dlamini Mandela) is a humanitarian, esteemed speaker, successful entrepreneur and respected thought-leader in South African and international business communities. She is the daughter of Zenani Mandela, Ambassador to Mauritius, and is the granddaughter of Nelson and Winnie Mandela, world-renowned leaders in the anti-apartheid movement in South Africa. Much like her grandparents, Swati is continuously challenging the status quo by taking initiatives to improve the welfare of all South Africans. While the Mandela name has certainly opened many doors and provided unique opportunities for Swati, she has always had to work diligently to establish a platform shaped by her family lineage but unquestionably her own.

Superficially, Swati's journey may appear to focus on being in the limelight, walking in entitlement that is often bestowed upon royal family members and frivolity. However, nothing could be further from the truth. Just beneath the surface, you find a woman of integrity and grace born into a family of dedicated social activists during a desperate and dangerous period in South Africa's history. Swati's childhood was overwhelmed by the oppression of living under the

apartheid system and later by upheaval during her formative years. She had to adapt to major changes in family dynamics that understandably occurred upon her grandfather's release from prison after 27 years of unjust imprisonment.

She and her family were pushed to center stage as that era came to an end, once political freedom was gained and her grandfather was chosen to lead the nation forward. As her grandfather quickly ascended to the office of President of South Africa, she too had to enter a completely foreign arena. She was only 14 years-old at that time and lived under an unwanted spotlight, never feeling free to pursue varied interests without public comment.

Just as Swati was entering her twenties, Nelson Mandela retired from the presidency. Nonetheless, her family's fame never subsided. Swati survived this thrust onto the world stage at such a young age. She eventually found that 1) being true to herself and 2) knowing her purpose is foundational to her personal and business successes. She now openly shares the secrets that helped her overcome the obstacles she faced, allowing her to become her "best self."

Swati's resume' reads like that of most. She completed college and spent approximately seven years in corporate public relations positions. The challenges she faced were most commonly secondary to being judged based on her family name - Mandela. Coworkers automatically questioned whether she was truly qualified for the position she obtained. This branding was unsettling for her, and the notion continually

floated around her work environments. Swati acknowledges that her last name would often help her get the interview. She constantly felt pressure to prove that she was more than qualified and capable of succeeding in the business arena. Ultimately, she had to sell herself and her experience just as much, if not more, than the next person.

People incorrectly assumed that she "was born with a silver spoon in her mouth," when nothing could be further from the truth. They would often ask her why she needed to work at all. The answer to these preconceived notions is obvious. She needed to earn money to provide for herself, and that response seems both common and reasonable. Swati was often told that she was only in a particular position or with the company because of who she was; she would add no value to the organization or team. She often felt she was being judged before she even entered a team meeting. This label drove her to work twice as hard to prove her worth, knowledge and abilities daily.

Swati remembers encountering managers who would be reluctant to assign her particular types of projects or to give her what they considered "too much work." They were concerned she could not handle it. Then there were others that took the opposite approach. Some people in supervisory positions would overburden her or become overly critical to determine whether she could handle the pressure. They humiliated and minimized her as an individual in an effort to determine if a "princess" could complete essential tasks and

survive the corporate environment. Initially, these behaviors caught her off guard. She was being treated as a specimen in some twisted experiment.

Over time, she mastered "the game" and was able to do more than simply meet expectations. She consistently proved that she could and would do the job just as well or better than her peers. This required her to align her work ethic with the expectations she had set for herself. The less she focused on her peers' thoughts and comments, the more she excelled. Freeing herself from negative and typically false commentary from others was one of the first significant steps Swati took in her personal and professional growth.

Swati experienced this passive-aggressive behavior at every job, no matter where she was employed. Both male and female counterparts exhibited this type of challenging demeanor instead of more cooperative engagement. However, she recalls the belittling actions to her person, and the intention to minimize her as a professional was more flagrant from the men.

Like many women in the workforce, she struggled to be taken seriously by her male counterparts. In her corporate positions, being a young, attractive and smart Black woman meant little. The typical attitude amongst men was that business concepts and strategies should not be discussed with women, much less debated. Swati admitted that this challenge was not shocking for her, nor was it unique to her circumstance.

Dr. Tana M. Session
Copyright 2020
Working While Black: A Woman's Guide To Stop Being the Best Kept Secret

Women's ideas being easily dismissed and sexual harassment were not necessarily considered inappropriate conduct during that time in her country. She had become desensitized to this unacceptable behavior. She began to take a step back and analyze the attitudes and actions of people in her workplace.

When she attended work-related meetings, she noticed her opinion would be requested, but it was rare that it would be considered. When she attended after-work events, she was treated as if she were there only for casual purposes. After experiencing sexism during her early career, Swati is encouraged that it is becoming less prevalent in the South African workplace.

Swati did not escape sexism by simply leaving the corporate environment. Years later, after Swati became a business owner, she experienced many of the same issues that she did when working for organizations—not being taken seriously because she was a woman. She often had meetings as an entrepreneur in restaurants and other casual environments. She did not initially realize that this would give some men the wrong impression about her during their discussion.

She had to be very mindful to keep the meetings focused on constructive business dialogue. She remembers having to conduct meetings over coffee or tea in public areas versus lunch or dinner to avoid any misconceptions about her intent or purpose for the meeting. She had to ensure that she was perceived as professional while also being personable. She

Dr. Tana M. Session
Copyright 2020
Working While Black: A Woman's Guide To Stop Being the Best Kept Secret

feels certain that men do not have to consider all of these things; they simply do not have the same workplace or entrepreneurial concerns.

Unfortunately, Swati had an added pressure. Whenever she was conducting business meetings with men in public venues, she had to ensure that she was careful about setting and maintaining very clear boundaries. As a Mandela family member, these types of interactions could be misconceived and propagate false information. She did not want these business meetings to be misconstrued and used for gossip around the country about her personal life or dating. It would hurt her professional efforts and bring negative attention to her family.

Swati is confident that she did not directly experience overt racial discrimination in the workplace. She believes this is because everyone knew that her grandparents were Nelson and Winnie Mandela. In retrospect, she does acknowledge that covert racism and the natural sequelae existed during her corporate experience.

Workplace constructs did and still do exist in which racial inequality is inherently present. Although no specific activity at the employee level could be easily identified, policies and procedures designed to impact people of color disproportionately should be reviewed and corrected. Institutional racism negatively impacts all persons of color, even when there is no direct or observable attack. Moreover, whether acknowledged or not, institutionalized racism hurts

the corporation as a whole and is simply unacceptable. People of color need to be in the room when critical decisions are made, and their voices must be heard if optimal performance is desired.

When Swati observed direct attacks on colleagues and knew they were racially motivated, she did not remain quiet. She did not have a problem speaking up when she saw or heard someone being mistreated or spoken to disrespectfully. In most cases, the behavior would stop because people quickly realized that she was unwilling to sit by and let it happen to anyone in her presence.

After establishing a solid track record with various South African corporate entities, Swati could safely say that she learned valuable life lessons, achieved numerous accomplishments that increased her confidence and understood nuanced strategies that allowed for success in that environment.

She decided to leave corporate employment to dedicate herself to her family. It allowed her to concurrently create a business concept permitting her to pursue a career that would better utilize her education, skill set and passions. Swati knew she wanted to be involved with work aimed toward the betterment of South Africa. She focused on these goals and moved forward when she had to face an unexpected challenge.

Her marriage ended in divorce when her daughter was only two years-old. She retreated to the safety of her mother's

home and quickly realized that she now faced a different set of challenges; regaining financial stability while attempting to provide and maintain a nurturing environment for her daughter. This life change was a difficult transition. It was undoubtedly an abrupt shift, but it led to her reawakening. It was truly a turning point. She had to decide whether to go back to a supposed stable corporate career or continue along a path that would establish her as an entrepreneur and lay a foundation for the humanitarian pursuits that she valued deeply. As a mother and a woman who was aware of her impact, Swati ultimately decided to continue her path as an entrepreneur with faith, perseverance and courage.

In part, her decision to seek peace about doors that were closed and avail herself to those that were now open was linked to a charge set forth by her grandfather. In a conversation after his retirement from the presidency, Nelson Mandela shared that the struggle for political equality was so immense that "economic equity" was not given the attention it deserved. He considered this a personal and national shortcoming. Mandela knew he had to pass the mantle to the generations to follow. Her grandfather encouraged her to lead. He challenged her to use the education, skills, interests and passions she had to create opportunities for building wealth while remembering to help others. Swati took her grandfather's wisdom and encouragement seriously.

She had to develop a process to help her determine how she would expend her energy and select the projects that

deserved her attention the most. Her priority was her daughter and stability. Beyond that, this would truly be a faith walk that required her to simply take one step at a time and trust God to lead her. With a young child and her strong desire to have a hands-on role in her upbringing, she knew flexibility with her work schedule would be essential. She decided to try her hand at two major initiatives: starting her own business and continuing her grandfather's desire to ensure that all South African children would have access to a library.

Swati decided to work toward financial independence by growing her business. Her priority was to build something for herself that would allow her to earn an income they could both live on and still leave a legacy for her young daughter. It was difficult, and she struggled financially for the first few years. There were times when she began to reconsider her decision and possibly pursue what had been comfortable in the past; a stable corporate job. She had to fight that internal battle constantly but ultimately decided to stay the course and push forward with her business concepts.

Before officially establishing her own business, Swati consulted for two years on a media project where she was responsible for fundraising. Consulting allowed her the flexibility she required. However, this remained a difficult time because the salary reduction was so significant that she could barely cover basic living expenses.

During this time, Swati and her sister also decided to do a reality show, which was less than successful and hugely

criticized throughout South Africa. This proved to be a difficult time for both of them due to the show's failure and numerous public attacks about this type of endeavor.

This reality show undertaking was designed to help people understand that the Mandela family members are not exempt from facing personal trials. However, the public backlash and negative publicity from the show made her even more aware of how carefully she had to carry the Mandela name and legacy as she went forward.

As she considered her next move, she did so with some trepidation. Her next step would take some forethought; knowing what she wanted, knowing the charge from her grandparents and seeing first-hand South African people's needs.

Not knowing what to do next, with no income at the time, she admits she was essentially penniless and could not even pay for herself and her daughter's basic survival needs.

During this trying time, she and her sister did not lose sight of their grandfather's wishes to ensure all children in South Africa had access to a library. They faced a unique challenge given that their grandfather was no longer alive. Many of the corporate sponsors who partnered with Nelson and/or Winnie Mandela, felt uncertain about where the foundation was headed without Nelson Mandela's leadership.

The foundation was transitioning into a memory center, which was a different business model than the original concept. The sisters decided to approach each of the merchandise

Dr. Tana M. Session
Copyright 2020
Working While Black: A Woman's Guide To Stop Being the Best Kept Secret

suppliers and start new partnerships. A few agreed to continue to work with them and helped reestablish their merchandising program to help fund The Mandela Library project.

Although they shared the Mandela family name, they had to demonstrate that they were credible representatives of the foundation. Establishing relationships and building new partnerships with vendors was tedious and required a lot of effort. It took five years, but they were able to ensure high-quality products while providing consumers with a level of consistency and excellence in the market. The merchandise is presently the primary source of income for The Mandela Library Project.

As a result of their successful vendor partnerships, the sisters also managed to enter into an agreement with a leading craft, curio and jewelry company in South Africa. They presently stock all their merchandise, which consists of apparel and notebooks.

Own Your Power

Swati has been on a journey to learn how to own her power. She was involved with publishing her grandmother's prison journal, which proved to be a very cathartic experience for her. The journal took her into the depths of the suffering and pain her grandmother endured. Swati was in awe of her grandmother's ability to be so resilient and determined to come out of those experiences unshaken, still holding her head up high. She drew strength from her grandmother's story.

Swati had the opportunity to learn first-hand about her grandparents' adversities as prominent figures in South African politics and civil rights. She learned what it took for them to be overcome and realized if her grandparents had that type of strength and power, then she must have it inside of her, too. Grace, integrity, resilience, strength and power were already inside of her. Swati now wants her daughter to draw those same qualities from her. She remains introspective and is determined to remain on the path to owning her power in all aspects of her life. Swati recognizes that she must be a living embodiment of her grandparents' core beliefs to be a conduit for the next generation.

Own Your Truth

Swati's daily pursuit is to operate in authenticity. She wants people to know that when you see her, "what you see is what you get." Living on an international stage has required her to learn to accept her whole self and the totality of her experiences—both successes and lessons learned. This mindset allows her to be pleased with who she is, whether alone or when she walks into a room as "Swati Mandela."

Own Your Healing

Choosing daily self-reflection and moving forward with continual and true forgiveness of self and others is what

Swati shares as her path to healing. As her grandfather's life became an exemplar of fortitude and forgiveness, Swati decided to deal with life's situations through the same lens. She had to learn to forgive those who hurt her intentionally and unintentionally. Whether it was friends, family or colleagues, it was forgiveness that ultimately made healing possible.

Divorce is never easy. It was challenging for Swati as she has always valued the family unit. But she realized that her child's well-being superseded her feelings. She chose forgiveness and soon learned that forgiveness created space for honest dialogue, collaboration and unity as co-parents. There is no forgiveness apart from love.

Own Your Worth

Like most women, Swati admits she has given too much of herself at times. She had to learn how to set healthy boundaries and how to say "No" without apology. She understands that women by nature are nurturers. Often it proves difficult to put yourself first. With time and practice, she has learned to say "No" without feeling guilty. She strives to be a servant leader, much like her grandparents. But she emphasizes the importance of self-care to rejuvenate and have the energy to continue serving others from a place of abundance and not deficit. Awareness of self and her worth motivates her to continue doing the significant work she feels she has been called to do.

Dr. Tana M. Session
Copyright 2020
Working While Black: A Woman's Guide To Stop Being the Best Kept Secret

Reporting To Another Black Women

Swati never had any overtly negative experiences working with other Black women. She feels she went out of her way to make certain they got along, had a good rapport and built solid relationships. She believes Black women are only better when they work together, support each other and not work against each other. In her corporate experience, there were few women of color in the workplace, so it only made sense to work together and mentor each other along the way. Swati has always worked from a level of respect for all Black women and feels we are all accountable for how we treat others, regardless of race or gender.

Mentors/Sponsors/Advocates

Swati's first mentor and advocate was her grandmother, Winnie Mandela. She learned so much "sitting at the feet" of her grandmother over the years. She received immeasurable support and guidance from her along the way. She still treasures the moments they shared as her grandmother poured love, strength and knowledge into her. She depends on her words of wisdom even now and shares them with her own daughter.

Swati has also found mentors and advocates as she developed business relationships. Unexpectedly, many of these relationships were with White men who recognized her potential. These mentorships happened organically. Sometimes it started with a simple request for help with a

Dr. Tana M. Session
Working While Black: A Woman's Guide To Stop Being the Best Kept Secret

business problem, and it grew from there. Her mentors have been instrumental and extraordinary in helping her to develop strong business acumen. Moreover, they provided support and assisted her in her business endeavors. She has found that men can be fantastic mentors, extremely consistent and always responsive.

Being the "Only One"

Like many Black women who are growing their careers or business, Swati has experienced being the "only one" in the room. Quite often on the international stage, she found that she was the only Black woman "at the table." Time and time and again, she used these experiences as opportunities to demonstrate that she earned her seat, brought a unique perspective and deserved to be present. Being in this position is not always comfortable, but she channels that energy towards leaving a positive and impactful impression on everyone she encounters. She hopes that she leaves them with a new or different perspective of women...and Black women in particular. She knows that being the only one sometimes means having just one opportunity to change the way women are perceived, eliminate bias and remove any stereotypes held prior to meeting her.

Own Your Destiny: Swati's Advice

Swati believes knowing who you are and what your gifts are to the world are perhaps two of the greatest catalysts for

131

success. Admittedly, this self-discovery may take time and maturity, but she knows we were all born with a special gift. She encourages others to discover their purpose and that unique gift.

She also holds to the belief that "no one can do it alone." Everyone should create a strong support group of mentors and advocates. It is imperative, especially early in your career. They can help you achieve success faster, avoid common pitfalls and help you identify your purpose. Support is critical to success.

Swati is also a firm believer in investing in yourself, whether through formal or informal education, such as reading, seminars or working with a coach. And much like her grandfather, Nelson Mandela, she is a firm believer in giving back to your community and the next generation. The returns of being a servant leader are immeasurable and beyond rewarding.

How Swati Gives Back

In 2019, Swati was appointed as High Commissioner at the Grand Assembly of the World Business Angels Investment Forum. In this role, she represents South Africa in the Global Women Leaders Committee of the Grand Assembly. The Global Women Leaders Committee is committed to leveraging unique access to the world's most influential women leaders. As such, it is no surprise that Swati is the co-producer of an authorized documentary about Winnie Mandela's life. Swati

co-authored the autobiography *491 Days* with the Nelson Mandela Foundation about her grandmother. She recently participated in publishing *The Prison Letters of Nelson Mandela,* in which she wrote the forward.

Swati is a Founding Partner and Shareholder of Qunu Workforce, South Africa's leading consultancy, creating equality in the workforce for those living with disabilities. She is a co-founder of the Long Walk to Freedom brand, a non-profit that delivers container libraries to disadvantaged communities in South Africa. And in 2017, Swati launched her luxury fashion line, Swati, by Roi Kaskara.

She and her sister offer the organic herbal Mandela Tea under the Long Walk to Freedom brand, which has been a huge success. The profits support literacy programs that have helped over 2 million youth in South Africa. Recently, they launched the Mandela Arizona Red Tea, a cold tea in the U.S. market, which has been a dream of theirs for the past five years.

Michelle Gadsden-Williams: Managing Director, Inclusion & Diversity

Michelle is the Managing Director, Inclusion and Diversity - North America for Accenture. She is also an award-winning author who released her first book, *Climb*, in 2018. She has held this C-suite position for other global organizations for many years. Michelle's father is a retired executive, and her mother is an entrepreneur, which prompted her to always have an interest in corporate America. She did not start her career knowing what position she would pursue, but she knew that "business" would be involved. Intention has been a common theme throughout her career path. She has had the grand opportunity of being exposed to some of the world's most influential leaders over the years. She realized the common denominator among them has been that everything they do is rooted in their "Why."

She has since incorporated an annual exercise of asking herself the following self-reflective questions: What ignites the passion within her? What does she really want out of life? She does this internal exercise at the top of every year. The results from that exercise are what drives her career in terms of what her next move will be, while positioning herself to start the year off in a positive way in a different frame of mind. She has

134

Working While Black: A Woman's Guide To Stop Being the Best Kept Secret

been deliberate and intentional but also determined to have passion around her "Why."

Like most people of color, Michelle admits she has faced inequalities in the workplace, like not being considered for a promotion or wanting a particular job and not getting it after working hard to prove she deserved it. But she has learned what is for you *is for you* in your own timeline, and has decided to look at each experience through a different lens. She asks herself questions like: "What could I have done differently? What else do I need to do? What up-skilling do I need to have? What certifications should I pursue?" She has used rejection as learning opportunities to go back and do more to make herself more marketable and more competitive and differentiate herself from everyone else. Her plan has been to close any possible gaps and make it that much more difficult for her not to be considered for that next opportunity.

Michelle believes it is imperative to set yourself apart because workplaces are highly competitive. She looks at herself as a product and feels everyone should know their "USP: *Unique Selling Position*," a term she learned while earning her undergraduate degree in Marketing. In other words, what is the one thing that will differentiate you from everyone else who does what you do? For example, when she accepted the Managing Director and Global Head of Diversity & Inclusion position for Credit Suisse, not only did she relocate to Switzerland, but she made the decision also to learn how to

135

speak German. This is called DIFFERENTIATION... and it can quickly change the trajectory of your career!

Own Your Power

Given that Michelle's father was an executive for many years, she basically had a coach for her entire professional life. Now retired, he still coaches her to this day, which, according to Michelle, is "Just Dad being Dad." She maintains she has a pretty good sense of self, but she certainly does not mind using herself as a protagonist to make a point. She will put herself out there or throw herself under the bus because that is how people learn. She followed the example of her mentors and sponsors, who did something similar, using themselves as the example to make a point.

This is not to say that is the only way to do it, but it is an effective way to do it. She advises women of color to figure out what will work for *them* and drive their individual career trajectory. One of the things that she has learned is that membership in the corporate elite just doesn't come easy, and in her opinion, it requires more than just intellectual horsepower. Being a member will require grit, a keen sense of self-awareness, and the right mentors and sponsors. Michelle advises everyone to maintain a willingness to perform at a higher standard consistently. As the old saying goes, "You have to be twice as good or smart to get half as much."

Her parents had very high expectations for themselves and their daughters (Michelle has two sisters, including a twin).

136

Their drive translated into their daughters holding themselves to a very high standard as well. She has always pushed herself to compete with the best and the brightest in school and the workplace. This is how she approaches her work every single day. She recognizes she is competing in a system that wasn't designed or built for women, particularly women of color.

To take ownership of her career, she would raise her hand for the top assignments and do all the things others would not do. This is the main reason why she decided to pursue her career outside of the United States because it would differentiate her from everyone else. This also drove her decision to attend a prestigious Ivy League institution and get her graduate degree. She was conscious of what would make her unique and different. Whenever she was being considered for a new opportunity, Michelle used these differentiations to her advantage to minimize the likelihood of being told, "No," without explanation. She was strategic in her approach.

Own Your Truth

Due to the perceived requirements of her "corporate uniform," as Michelle calls it, she would flat iron her shoulder-length natural hair to wear it straight for work. While working for a prestigious Wall Street financial services firm, there came a time when Michelle suffered a medical condition and was temporarily unable to lift her arms high enough to straighten her hair. She was torn about what to do with her hair. She ultimately opted to shed her corporate uniform

Dr. Tana M. Session
Copyright 2020
Working While Black: A Woman's Guide To Stop Being the Best Kept Secret

and walked into the boardroom with her kinky curly hair on display for the first time in her career. Of course, there were some stares and confused expressions on her colleagues' faces, but her hair was no longer the topic of discussion by the end of the meeting. What she learned from standing in this truth was to embrace all of who she is, without compromise, because at the end of the day, it was about her knowledge, skills and abilities...not her hair. If her hair made others uncomfortable, that was not her problem to solve. She has worn her hair naturally off and on throughout her career ever since, without further consideration for the impression others may have about her. She knows who she is and the value she brings to an organization and stands in that truth every single day.

Own Your Healing

In 2006, Michelle was diagnosed with Lupus. This was at the height of her senior-level career. She was forced to put a pause on her career pursuits and take a step back. At one point, she put her career before her health and had to take a considerable amount of time to focus on her well-being. She enlisted the help of a wellness coach, and through that relationship, she began to understand who she was truly meant to be. Her lupus diagnosis really did it for her. She had to decide to do something different and maintain her sense of wellness, or she would not be here much longer. Her diagnosis was an actual life-or-death situation.

Dr. Tana M. Session
Copyright 2020
Working While Black: A Woman's Guide To Stop Being the Best Kept Secret

As career-focused as she was, Michelle had a decision to make. She had a blood clotting disorder which she could die from. In her heart, she knew she could not continue working at the pace she was going. Michelle had to refocus, reprioritize and reshape things in her life. She began to look at life through a different prism.

Michelle started to look back over her career and considered how she put work before her health. For instance, before moving to Switzerland in 2006, she commuted every week, Sunday through Thursday. She would leave for Switzerland Sunday night, arrived Monday morning, and then fly back to the U.S. on Thursday evening. Michelle maintained this hectic schedule for two years.

On November 15, 2015, at 7:33 am, Michelle got up the courage to walk into her boss' office and resign from her position on Wall Street. She needed to take a break. That was one of the best decisions she could have ever made for herself. The time had come when she had to make concessions in her career and decisions for herself that would impact the rest of her life. Michelle admits sometimes it takes a devastating diagnosis to put things into perspective, and that's exactly what happened in her life. She was on the fast track and had never taken a break in her entire career.

During this career break, Michelle returned to New York permanently and started her own consultancy practice along with my husband, who was also her business partner. She was doing entrepreneurial ventures and it was all hers. She built it.

It was her brand. During this time, Michelle admits she learned a lot about herself as a leader and business model, and feels this was some of the best times for her and her husband.

She loved the work and enjoyed every moment. Running her own company was exciting but also eye-opening. At first, she was fixated on the sexiness of being an entrepreneur. Yet, when she finally became one and had to chase invoices so that payments could be made on time, it was no longer fun or sexy. Eventually, she realized the enormous benefits of having a large infrastructure, like being employed by a vast corporation receiving a regular paycheck. She learned a lot about herself as a business owner, which she still applies after returning to corporate America, and admits overall entrepreneurship was a great experience.

Michelle feels everyone needs to experience entrepreneurship because that is where you really learn about unique business models and how to manage budgets in a most meaningful way. She had to learn to do things for herself for the first time because she did not have an extensive infrastructure or a major company backing her. Michelle did not have an assistant doing all the administrative duties she needed to accomplish daily either. This was a huge learning experience, but she feels she is a better corporate professional as a result of her experience.

Own Your Worth

Michelle believes all women should learn how to negotiate on their own behalf. Like most women, early in her

Dr. Tana M. Session
Copyright 2020
Working While Black: A Woman's Guide To Stop Being the Best Kept Secret

career, Michelle struggled with asking specifically for what she wanted, whether it was negotiating a salary or a raise.

At one point, Michelle was working for a company and did not realize, in comparison to her peers, her salary was much lower than theirs. During year-end reviews, she and her White male boss were reviewing her merit increase and bonus amounts. Her boss noticed the difference in her salary compared to everyone else in the department, so he gave her a significant raise to bring her within range of her peer group.

At first, she was a little angry with the White female executive who was responsible for hiring her. Michelle was confident this executive must have had a seat at the table and had access to sufficient information to understand salary ranges, such as what was fair and equitable across the team, where other individuals fell within the range, and other compensation data. Michelle was disappointed that the woman who hired her did not ensure she was compensated fairly and equitably. Over the years, Michelle has coached Black women to help others understand when they are being low-balled in terms of their salary from the start of their career. She feels it is important for them to understand they will never catch up unless they have someone who will give them a substantial increase along the way, which was fortunate in her case.

Michelle advises Black women to ask for what they want and deserve. She feels people of color tend to be happy to be invited into the room and be considered for an opportunity;

141

Dr. Tana M. Session
Copyright 2020
Working While Black: A Woman's Guide To Stop Being the Best Kept Secret

therefore, we do not want to rock the boat or ask for more than what we think we deserve. This mindset is a cultural nuance that most African-Americans were reared with for generations. Culturally, Black people tend to be grateful just to have an opportunity to either interview or be considered for an opportunity. And asking for "too much" is not even a consideration. Generally, Black people will not ask for anything above and beyond. They feel they need to get the job first and let their work will speak for itself and hope they get rewarded properly for their efforts.

Michelle encourages Black women to have courageous conversations, even though it will be uncomfortable at first. There are strategic ways to ask for what you want and negotiate on your behalf, but it does take practice. She recommends practicing with a mentor, sponsor, a peer or friends in Human Resources. It is also important to do some homework and research salary benchmarking data in advance of having conversations about salary or a raise. Michelle feels Black women should go into a salary conversation well informed and courageous enough to ask for what they feel they deserve based on their background, experiences, education, contributions to the organization, salary benchmarking data and any other valuable and useful information. Michelle knows from personal experience women tend to doubt themselves, but she feels there is no room for self-doubt when negotiating. She advises when you hear that inner voice saying, "Well, you know, don't ask for that and don't shake things up. Just ask for

the bare minimum, and everything else will come to you later down the road"...ignore it immediately!

Reporting To Another Black Woman

Michelle has worked for two Black women in her career and felt each time the experience was positive. She would liken it to a Big Sister/Little Sister relationship. They were there to help her win. However, she has witnessed these relationships turn out badly for other colleagues. For example, instances where a senior woman would roll up the drawbridge because she has made it across, and leave her sisters behind to figure it out on their own. Fortunately, Michelle only witnessed this behavior from a distance.

Mentors/Sponsors/Advocates

A former track athlete in high school, Michele still enjoys sports and describes a mentor as a personal coach and a sponsor as a sports agent. Just like in sports, they each serve a unique purpose in your career. A mentor, or a personal coach, is the person who is going to help you unpack the terrain of an organization, allowing you to assimilate into the culture and understand the unwritten rules and office politics. These are all of the traditional things Black women need to know in order to be successful.

However, a sponsor, or the sports agent, is the person who sits at the table and is negotiating, advocating and championing for you to get to the next level of leadership. A

sponsor is a person you want to have in your corner because they have decision-making and influencing power at the table where it counts. One of Michelle's mentors once told her if she ever feels like she is the smartest person in the room, she should find a new room. Well, that stuck with her, and she set out to find several rooms. She would pull up a chair and act like she belonged, even when she knew she had no business sitting in the room.

Michelle is adamant that Black women need both mentors and sponsors, and has made it her business to have them throughout her career. She has also strategically broadened her network to surround herself with others who do not necessarily look like her. She also believes in "reverse mentorship" because there is always something to learn about other people and their experiences. Reverse mentorship is not necessarily related to hierarchy, where the individual is more senior than you, and they get to teach you everything. There is something to be learned from your life experience as well. For example, as a Black woman from the United States, she was living in Switzerland. Her mentor and sponsor was the Chairman of the company, and he was a Swiss-German man who really did not have access or exposure to people of color, at least not in his social circle.

They would have open and candid conversations about being an African-American and what that means. She would share what a "day in the life" for her was like, letting him know what she had to deal with on any particular day.

Dr. Tana M. Session
Copyright 2020
Working While Black: A Woman's Guide To Stop Being the Best Kept Secret

One example she shared with him was her experience with the UPS delivery man in her neighborhood in New Jersey. One day, while standing in her driveway and talking to her White neighbor while holding their child, the deliveryman automatically assumed she was the nanny! Because she was a Black woman and her neighbors were primarily White, she explained to the Chairman how this was a perfect example of a common microaggression and bias in its truest form. The two of them would have some intense conversations around real-world situations. She shared with him when you overlay microaggressions and bias with the intersectionality of race and gender, it shows up in the workplace in negative ways. She was able to help him understand there is extra baggage that people of color have to carry due simply to their life experience outside of the workplace, and everyone needs to understand that.

Being the "Only One"

Michelle has often been the "only one" who looks like her in a room, but chose to view the experience as a learning opportunity for people to understand that we all have different life experiences. We do not engage the same or have the same perspective about things. She admits her point of view may be a little different because of the nature of her work in Inclusion and Diversity. She has learned to use being the "only one" as an opportunity to promote awareness and education on her differences. She gives an example of being in a room with ten

people: five men and five women, and she would be the only woman of color.

Some individuals might say that because they are a group of five women, they must all have the same experience, but in reality, they do not. This is where the conversation about intersectionality comes in because she has a double bind. Not only is she a woman, but she is a person of color. It is not possible for her to take her skin off and pretend to be something else. She leads with her ethnicity first. She is a Black woman, and here is her experience. Let her explain what a "day-in-the-life of" looks and feels like for her. She revels in her differences and enjoys those conversations that others might find difficult to have. She truly enjoys that part of who she is and how she is wired and contributes all these factors in those conversations.

What Would You Change?

Michelle recalls the adage that ambitious people often marry ambitious people. She found a true life partner in her husband, David. They have been married for over 20 years, and both share similar aspirations, goals and dreams about their lives and careers.

However, Michelle vehemently disagrees with Sheryl Sandberg's opinion that you can have it all. Maybe some can, but she certainly cannot. She was adamant about having a successful career, even as a young girl. On her first date with David, she recalls telling him she wanted to be a successful

146

executive and work for a global Fortune 500 company. She knew that she wanted to work in an organization, manage people and go global. David was and still is her biggest supporter.

When she accepted the opportunity to move to Switzerland, David retired from a 22-year distinguished career with AT&T so she could realize her dream. Over the years, one of the things she has found difficult in her career is the challenge of balancing both career and being a wife. Michelle and David do not have children, but while she was succeeding professionally, she was failing in other aspects of her life, like managing her health and being a wife.

One year, David surprised her with a vacation to Monaco. They were both excited to go because they were celebrating their anniversary and her recent promotion. Michelle made the mistake of bringing her Blackberry® and two other cell phones with her on vacation. This was a peak time at work for her, and she wanted to dig in and do the job since she was newly promoted. She was on her Blackberry® constantly. After about two days of this, David finally looked at her and asked if she was willing to vacation with him or planned to work the entire time. She saw the disappointment in his eyes, and from that point, she told herself she had to do something different. She realized David sacrificed everything for her, and the least she could do was be present for him and give him her undivided attention. Since then, she has decided to focus on what matters most—her health and her marriage—and

Dr. Tana M. Session
Copyright 2020
Working While Black: A Woman's Guide To Stop Being the Best Kept Secret

she sticks to that every single day. Michelle admits if she could do something different, she would change some of the ways she compromised both along her path to success.

Own Your Destiny: Michelle's Advice

Michelle is a huge supporter of women lifting others as they climb. In her opinion, your ambitions as a professional must be broad enough to include others' aspirations. She currently sits on multiple non-profit boards and volunteers her time to causes and other activities she is passionate about, including education, health care, social justice, the arts and equal rights. She spends a good portion of her time raising money for causes important to both her and her husband. Together, they are passionate about focusing on reaching back and pulling others along and helping them advance.

She believes it is her indelible responsibility to ensure that another person, particularly another individual who looks like her, succeeds. It is her goal to guard, protect, champion, advocate and mentor others. Her most significant piece of advice for other women of color is, do not roll up that drawbridge - but rather take others along the journey with you. At the end of her journey, she can honestly say all she ever wanted to do was to leave a place in better condition than when she entered it. If she can say that she accomplished that goal—even if just a little bit—she will consider herself successful.

Dr. Tana M. Session
Copyright 2020
Working While Black: A Woman's Guide To Stop Being the Best Kept Secret

Valerie Taylor: Executive Senior Partner

Valerie Taylor has worked for her current employer in the executive search industry for over five years. However, she started her career in technology. In the product delivery line of business in technology, she was in a high-demand position working seven days per week and long hours. When Valerie decided she wanted to have a second child, she knew she had to make a career change. Based on her technical and people-connecting skills, transitioning to professional executive recruiting was a natural progression. Like many career-focused women, she decided to make motherhood a priority and transitioned to a career with a better work-life balance.

Valerie faced many adversities along her career path, but most of them were based on her light skin tone. Being the child of a biracial couple, Valerie is very light-skinned with soft long hair. Often, people did not accept her as Black or White. Those around her would regularly question her ethnicity. They would ask her, "What are you?" "Tell me about yourself?" "Where is your mother from?" Being asked to identify who and what she is has been a constant in her life ever since early school age. However, Valerie admits most of her adversity has been based on establishing herself, not her ethnicity.

Dr. Tana M. Session
Copyright 2020
Working While Black: A Woman's Guide To Stop Being the Best Kept Secret

Coworkers would ultimately figure out her race when they saw who her friends were and saw that her husband and children were clearly Black. Sometimes she would see the look of surprise on their face. The color issue would always somehow surface in the workplace, but she has faced it by doing her best work consistently without fail. Valerie chose to let her work speak for itself and not get caught up in others' expectations of who or what they thought she was. Her constant mantra and advice to others is to be good at what you do and set your own expectations. At the end of the day, she believes that companies want you to do a good job, help them make money and run a tight ship.

Valerie faced the most blatant form of discrimination in the workplace when she was a project manager in the late 1990s for a software company that manufactured printer drivers. The company's biggest client was a Japanese manufacturing company. She was the only African-American woman on the management team and was tasked with presenting quality assurance metrics. However, her manager told her the Japanese client would not be receptive to an African-American woman presenting, which could be problematic. Of course, this caught her off guard, but when her manager asked her what she thought she should do, Valerie responded that she planned to present her data at the meeting.

The company put her in a position to make the final decision herself. She assured them she would be respectful

150

and present the data she collected to the client. In the end, the presentation went well. Of course, she admits to being uncomfortable thinking about having to present, knowing she was not a welcomed addition to the meeting. She did not let their ignorance impact her presentation. Instead, it made her more determined to show the client and other managers on her team that she knew her facts and information, and she presented it confidently and persuasively. The client was respectful, and it worked out for everyone.

Valerie did not let others' expectations deter her, although the comment did irritate her deep down. She stands firm on having her act together, letting her work speak for itself and focusing only on what she has control over.

At various points in her career, Valerie experienced inequality in the workplace, especially when promotions were not based on revenues. When promotions were based solely on merit, she was passed over and feels certain there was a perfect trifecta involved against her at the time: (1) African-American (2) woman and (3) over 50 years old. She had to be the epitome of the squeaky wheel by questioning why she was not promoted when her work clearly spoke for itself. She approached two senior leaders after not being promoted after six years, all while being a high producer leading a successful team. She was irritated by the notion she had to initiate and drive the conversation about her own progression within the company. Why did she have to be the one to bring it up? In her heart, she knew there was something else going on. Looking

Dr. Tana M. Session
Copyright 2020
Working While Black: A Woman's Guide To Stop Being the Best Kept Secret

around, she realized there were no other African-Americans in senior leadership.

Valerie did her part in bringing other African-Americans and women along in their careers. She never encountered any issues with White men or women reporting to her, but she was strategic in hiring diverse team members. Valerie took pride in hiring Black men and promoting women, which was a rarity in technology in the 1990s.

Own Your Power

Valerie has experienced great success in her career. She attributes quite a bit of it to learning who she was and embracing her power along the way. She was not afraid to have a voice and speak up for herself. She made certain to get airtime with influential people and rarely spent time with those who could not do anything for her in the long run. Complaining or venting with coworkers served as an outlet, but she knew she had to take action and speak her truth to people who could impact change on her behalf. Valerie recognizes this can be intimidating and uncomfortable, but believes you have to step out of your fear—that is where your true power lies. Look for advocates. They may not look like you, but that can prove to be a bonus. Gaining different perspectives can be very beneficial. Valerie recommends building a track record of success and forging relationships with the right people to help you own your power in the workplace.

Dr. Tana M. Session
Copyright 2020
Working While Black: A Woman's Guide To Stop Being the Best Kept Secret

Own Your Truth

Valerie has always set high expectations for herself and others. Part of learning how to own her truth was accepting that not everyone is at the same level and does not share the same aspirations. Valerie realizes her work is only as good as the effort she puts into it, and she can recognize - and be honest with herself - when she is doing well and when she is not. Sometimes she is not performing at a high level, but takes responsibility for when she falls short and does not hold others accountable or make excuses. Admittedly, sometimes she still grapples with her success and achievements because she feels she always has to prove her capabilities. Valerie is almost certain these feelings are directly linked to being a woman, an African-American and a bi-racial woman, and suffering from imposter syndrome at different phases in her career.

Own Your Healing

Valerie had to go through a healing process during her path to success. Her father was a very successful African-American businessman and political figure. He was an Assemblyman and ultimately became the first African-American mayor of Inglewood, California. Through his career success, he had many flaws and demons. She suffered from non-forgiveness of some of his behaviors because she focused on the negatives, and at one point, she was not able to fully appreciate her father's success.

He came from very humble beginnings and grew up without parents. She gets sad thinking about his childhood and how hard it was for him, and she struggles between admiring him while wanting to hold him accountable for his lack of parenting skills at the same time. Since his death, Valerie has allowed herself time to accept how hard it was for him and appreciate what he did for her and her sister. They were both able to attend college debt-free, and he was there to bail her out of bad situations over the years.

She had to heal and let go of past feelings regarding her father, which held her back for many years. He was her first mentor. Her father helped her develop into a confident person who does not care what others think about her. He helped her believe there were no limits on what she could achieve, and she tells her daughters the same thing. Her father was a bit of a militant and enforced the idea of doing what you want to do and believing you are as good as anyone else. This belief has been a solid foundation for her success today.

Own Your Worth

Valerie has experienced the same challenge as many other women when negotiating on her own behalf, whether salary or promotions. She has learned to be strategic and calculated in her approach, but always knew her work would speak for itself. Over the years, she has learned companies can make special accommodations, but you have to ask for what you want. No one is going to GIVE you anything. If you want that

raise or promotion, ask for it, but have the business case to back it up. Once you have done this successfully a few times, it will become more natural, and there will be less chance you will leave money or opportunities on the table.

Mentors/Sponsors/Advocates

Valerie has had mentors throughout her career. Her first mentor was her father. When she was in the technology industry, she had a White male mentor. He helped her understand how to collect data and report it out to stakeholders. He was a big advocate for her and helped her get promoted to Project Manager.

She also had an African-American woman as a mentor. They were assigned to each other through the company's mentorship program. She provided Valerie with great insight and strategies to help her along her career path, and she was a great sounding board as well. Although they no longer work together, they continue to mentor each other in any gaps they still have in their respective careers and areas of expertise. Valerie believes in the importance of having and maintaining mentors and aligning with advocates or sponsors in the workplace, especially early in your career. These relationships will have a significant influence throughout your career journey.

Being the "Only One"

The impact of being the "only one" can have a long-lasting effect on African-American women. From Valerie's

own experience, she felt left out and did not feel she belonged to any particular group in the workplace. There was no one at her level to whom she could relate. This division made her a little angry because she immediately became acutely aware of the lack of diversity. At one point, she wondered if any other African-Americans existed in the company because she never saw anyone she could identify with regularly.

One year at the company's President's dinner honoring the top earners for that year, she was the only African-American top earner out of 200 people being honored. She could not believe no other African-Americans were in attendance. Did they not meet their numbers? She found this to be very uncomfortable and absurd. She just wanted to get her award and go back to her room. Looking around at her colleagues, she just did not want to be there any longer. The lack of diversity took the joy out of what should have been a celebratory career milestone.

What Would You Change?

Valerie readily admits if there were anything she could change about her path to success, she would have gone to a different college, one with more diversity. After attending an all-Black gang-based high school, Valerie attended a preppy White Catholic college surrounded by wealthy White students. Because she was such a light-skinned,

some students assumed she was White. Sometimes she was the only African-American student in her class. She did not have a chance to socialize with Black students or have more Black experiences in college. There were no sororities for her to join and no African-American student clubs or events to participate in while in college. She had to actively and consistently seek out Black experiences off-campus. She feels the bonds with other Black students would have been helpful, and her college experience could have been richer in a more diverse environment. She is certain having relationships with Black college students would have been beneficial in her career, too. Looking back, she thinks the lack of Black connections in college probably hurt her in her early career.

Own Your Destiny: Valerie's Advice

Being a Black woman is a tremendous and beautiful position to be in today. Embrace what and who you are every single day. Use your talents to your advantage. You can be extremely successful, but you must take pride in your work. If you come to a point where it is no longer working for you where you are, take your talents elsewhere. Be sure to find a mentor in your industry you can relate to and make strong alliances within your company with people who know who you are and what you are working on. Emulate the positive behaviors and interpersonal skills of the top producers or

revenue makers. Find the people who know what they are doing and do what they do. Network and use your power of persuasion, conversation and social wits to become known in the right circles. Finally, choose how you want to be branded and stand by that brand in all that you do; Be consistent. The sky is the limit, but sometimes you will have to shut up and listen!

Dr. Tana M. Session
Copyright 2020
Working While Black: A Woman's Guide To Stop Being the Best Kept Secret

Davida Lara: Executive Vice President

Davida Lara has been in her current role as Executive Vice President for just over two years. She relocated from Connecticut to Los Angeles with her husband, two daughters and two dogs. Her role at the new company has been a dream come true, and her family has adjusted to the #LALife quite well. However, her road to EVP was paved with many personal and professional setbacks. At a very early age, she had to learn how to persevere in spite of where she started and not succumb to her environment.

Prior to moving to Los Angeles, Davida lead the global payroll group for one of the largest private equity firms in New York. In her role, she was responsible for portfolio restructuring and the entire payroll organization. She had a corner office, large desk, expense account and a global team reporting to her. Davida started speaking at industry engagements worldwide, where she emphasized the importance of linking human capital management and payroll to help organizations meet their goals and objectives successfully. Additionally, she began offering her expertise to some of the portfolio companies her organization managed. She was set in her career and planned to stay with the company, but then Davida received an unsolicited call from a recruiter looking

159

for someone with her experience to join a Los Angeles-based firm and lead their payroll function. Now she proudly states she is responsible for "paying all of Hollywood," which is not a stretch from the truth!

Davida started her career in Human Resources in the music industry. She understood the people part of Human Resources, including payroll. She always had a passion for discovering how things worked under the hood of organizations. She wanted to go beyond just doing the job and learn how it impacts the overall company. Davida also understood if she knew how people were paid and the mechanics behind it, she would be the last to be downsized or eliminated in a company. She had a passion and talent for dealing with numbers and understanding the people behind the numbers.

Since this was her passion, she decided to focus her experience on compensation and benefits. At the time, this area of expertise was not something she could go to college to learn because it did not exist as a degree or even a certification program. As a result, she was in high demand globally and spent several years traveling back and forth to London. She spent time in Poland, Prague and the Czech Republic during her time abroad. Growing up, these were places she never imagined going to, much less becoming recognized as an expert in the field.

Davida states she had a pretty normal and happy life until the tender age of seven, when her mother was murdered.

Her mother gave birth to her in the early 1970s when she was 14 years-old; her father was 15 years-old. Davida actually attended her mother's high school graduation when she was four years-old and thought it was normal. She vaguely remembers her household being very diverse, which made her feel like a kid from another planet, but she was happy.

Her mother was killed in 1980 by her best friend due to a fight amplified by heroin use, which was prevalent at the time. The friend wanted money from her mother, and her mother decided to fight her friend with a butcher knife, resulting in her death. This unfortunate event completely changed Davida's life because she learned at that point how much she was not wanted.

Her grandmother and other family members tolerated her because her mother was immediate family. But there seemed no desire for her to exist. She started to feel the pain of that when her grandmother became abusive, partly because she looked a lot like her mother. She is still the walking image of her mother. Her grandmother resented her and did not hold back in showing her true feelings towards her. Also, during this time, her younger sister was born.

Her grandmother would drink and take her feelings out on Davida, even occasionally calling her by her mother's name. At eight years-old, Davida was molested by her uncle. When she told others what her uncle did to her, she was met with disbelief and accusations of trying to ruin the family. Also, at eight years-old, she was busy trying to be a kid playing

"red-light-green light" with the neighborhood kids and was caught off guard when she cramped and got her period in the middle of a game. At eight years-old! Davida feels like this was when she became a different person. She calls it her "Before and After Mommy" life.

Davida remembers her grandmother being consistently abusive until she turned 11 years-old. At that point, she felt something turn on inside of her. She realized she didn't deserve to be treated like that by anybody anymore. It all came to a head when her grandmother threw an iron at her. Davida threw the iron back at her grandmother and was sent to live with her father's family, who did not really know her at all. They knew she existed and accepted she was family, but her father was a crackhead in the 1980s and lived on the streets. Her paternal grandmother did not want her to live at her house because it was full of men who were all addicted to crack. Eventually, she was sent to live with her father's sister, who was physically and emotionally abused by her boyfriend.

By the age of 15, Davida was hanging out with drug dealers and took on an aggressive, driven and masculine personality, which was required in the streets. She did not take "No" for an answer, and was determined to get what she wanted. Surprisingly, her school grades did not suffer during this time. She was hanging out, drinking a "40" (40 ounces of beer from a bottle) and smoking weed, all while getting A's in school. At the age of 17, she connected her aunt with victim services so she could escape her abusive relationship. When

162

her aunt was relocated through the victim services program, Davida also moved into her own apartment in the Brownsville section of Brooklyn. She was working a minimum wage fast-food job and was able to get her own apartment. Living on her own at 17 years-old, Davida did not feel there was anything she could not face in life. She went on to attend Cazenovia College in Syracuse, New York, as an independent student and lived on campus while keeping her Brooklyn apartment through subleasing.

Over time, Davida built a bond with her paternal grandfather. He supported her financially and sent care packages to her while she was away at college. At the age of 18, her grandfather fell ill, close to the end of her freshman year. When she returned to Brooklyn for the summer break, she never returned to Syracuse because she wanted to be near him while he was ill. Over time, Davida was eventually able to return to school and finish her undergraduate degree and her MBA; both paid for by tuition reimbursement programs available through her employers.

She eventually found a job as an office assistant with a new record store chain with headquarters in London. She went on to expand her duties to include setting up stores for various artists' in-store Meet & Greets, and became the liaison between the record stores and the various record labels. At 21 years-old, Davida was promoted to start the first Human Resources department for the chain. The company relocated her from her apartment in Brownsville to a high-rise

apartment building in Stanford, Connecticut. She felt like George Jefferson from the television show, *The Jeffersons*. She had a doorman and amenities, unlike anything she had ever experienced before. This new position was also her first exposure to corporate America.

Working for a London-based company, Davida experienced sexual harassment, inappropriate language, drinking and smoking marijuana in the workplace. Since it was her first experience on the corporate side of business, she did not know if the behavior she experienced was acceptable or not, since it was all part of the culture and they were in the music business. She was a young executive and the head of the Human Resources department, so whom was she supposed to complain to or even ask if this was appropriate?

Although she did not experience racism directly, she witnessed it and had to address it immediately. For example, she had to correct a store manager for calling Black male employees "boys" or "colored boys." She turned it into a teachable moment for him.

Davida realized early in her career that she would need to work on her diction and Brooklyn accent if she wanted to advance. She was a girl from Brownsville, Brooklyn, with a strong accent and was very comfortable in her own skin. She did not feel she needed to change who she was, but she realized this was an area she wanted to work on for her own self-development. As the young Black female head of Human Resources, Davida engaged with more senior-level executives

Dr. Tana M. Session
Copyright 2020
Working While Black: A Woman's Guide To Stop Being the Best Kept Secret

in the company and wanted to be respected. She quickly realized no one at that level spoke with the same diction or accent she had, which made her stand out even more.

Davida eventually moved on to work for a large food service company where she had an interaction with another Black woman who was one of her employees. This woman referred to Davida as a "nigglet" and "pickaniny," two very derogative terms used toward Black slave girls. The woman told Davida, "I'm not going to be told what to do by a little nigglet pickaniny." At the time, Davida was not familiar with the terminology because she had never been exposed to the South. She had to ask her father's mother what those terms meant since his family was from the South. When her grandmother explained the terminology to her, she realized how hurtful and insulting this woman's comments were towards her. The woman refused to be managed by Davida, who was only 25 years-old at the time. This was also Davida's first time experiencing racism from another Black person, and she was the first employee Davida ever had to fire, which she did with pleasure.

She never experienced racism or being marginalized in the workplace by any White employees or managers. She believes it is because she demanded and commanded respect and walked around with a look of "I wish you would" on her face. She was not the angry Black girl, nor did she have to roll her eyes or neck to get her point across, but she was knowledgeable and technically sound in her skills.

As she started to focus her expertise more on the payroll and finance side of Human Resources, there were fewer and fewer women in her peer group. She had exposure to compensation and saw the pay gap between her and others. She knew she was not being paid equitably compared to some of her male counterparts. She was fine with the pay gap if they had more experience, because she realized early on that *fair* does not always mean *equal*. Plus, she recognized she was walking into an already existing system not necessarily built for her success. Being treated unfairly as a Black woman was part of societal norms. Over time, she learned how to negotiate for herself but realized many women, not just women of color, struggle with that ability. She believes there is something about negotiating as a woman that feels demanding and not nurturing, which takes some women out of their comfort zone, but it is necessary.

Own Your Power

Davida understands that confidence is not cockiness. To own her power, she has used her confidence more than anything else because she finds it highly contagious. People are more likely to approach her in a positive manner because she approaches them positively. She looks at power as her reach and understands she is now at a level where she has more range and influence. She is conscious about putting a lot of effort into her quality of work and showing up, because she understands people look to her to set the standard. But she also does not hesitate to correct those who fall short under

Dr. Tana M. Session
Copyright 2020
Working While Black: A Woman's Guide To Stop Being the Best Kept Secret

her guidance. She uses it as a teachable moment because she wants others to be just as successful as she has become over the years. She sees her power when those she has managed and mentored are successful.

She is also comfortable with people reporting to her who know more than she does. Over the years, some people on her team have been in the finance and payroll field for over 30 years, yet she comes in at a higher level with fewer years of experience. She is sensitive to how that can make others feel and knows it can be daunting to a degree. But she also stands confident in the power of her knowledge and experience. She is comfortable with not being the smartest person in the room, and she never discounts anyone's experience. She feels this approach is what makes her team respect her as a powerful leader. Davida sees this as a brilliant dance because she has the most fun when she can open a door or advance somebody to their next level of success, then step back and watch them be amazing. This is by far better and more sustainable than someone asking her for a "hookup" for a position or promotion, because ultimately they have worked to earn it and can now own THEIR power.

Own Your Truth

Davida knows when people meet her they think she grew up in a *Cosby Show* family. She does not shy away from her humble beginnings and openly shares her story on public stages and with her mentees. She starts each of her speeches

with, "How are you doing? I am Davida, and I am from Brooklyn," because she is so proud of that fact. She says that statement with a deeper meaning than people can appreciate. She is saying, "I'm not supposed to be here!" "I was told I am never going to be shit!" When she says that opening line, it launches her to be her true authentic self and stick her chest out with pride. She does not care if her authenticity makes others uncomfortable. Her truth does not make her uncomfortable, and this is why she is so comfortable in her skin. She sees her truth as amazing, and as a result of her sharing her own truth, others have openly done the same.

Davida has been told she is highly disarming because she can enter a room full of tension and adversity, and her energy will set everyone at ease. She has made her office a safe space where people can freely enter, let their guard down, and stand in their truth so they can walk out and go back to being their amazing selves and never feel judged.

Own Your Healing

Davida works to constantly heal what was broken in her. At the age of 16, she attempted suicide and was admitted into the hospital. Part of her conditional release was a requirement to go to therapy, which she did. Since then, she has tapped back into therapy off and on throughout her adulthood, including marriage counseling. She gained an appreciation for talking to someone who was not going to judge her, which was part of her healing.

Dr. Tana M. Session
Copyright 2020
Working While Black: A Woman's Guide To Stop Being the Best Kept Secret

One area she struggled to heal from was being molested by her uncle. He was still around and an active part of her life. He even attended her wedding! She eventually told her husband what happened between her and her uncle. She feels one of the reasons she may have married her husband was because he protected her from her uncle and would not leave her alone with him. She admits one of the best things to happen to her was when she received the phone call letting her know her uncle died. She felt something open up and release inside her soul. Davida still felt somewhere in the back of her mind, regardless of how much success she experienced in her professional and personal life, that the molestation left a scar on her that made her a tainted individual. She felt unclean because she "allowed" it to happen. In some ways, Davida admits she still suffers from the molestation, especially as the mother of two daughters.

When they were growing up, she constantly watched them and was overly cautious about whom they spent time with, especially if men she did not know were involved or going to be around them. Now her daughters are older - one in high school and one in college - and can take care of themselves. But Davida feels this has been a scar that has been slow to heal.

Own Your Worth

To own your worth, Davida feels you have to be willing to make choices. She feels women far too often do not take the time to have a conversation with themselves about what

is fair and equitable. Her experience has led her to believe some women are surprised they have to negotiate on their own behalf and, therefore, struggle in the process. She asks herself a couple of key questions before going into the negotiation process: "What do you want this compensation package to do for you? What would I expect someone to pay for the value I bring to the organization?" The only time she has struggled in the negotiation process is when she has not given these questions any consideration prior to sitting at the table. Whenever that happened, she would ask to pause the conversation and return to the negotiation process with answers to those self-evaluating questions.

Because of the nature of her role, sometimes she would have access to see compensation for others in the same or similar roles, but she knew she could not use that information in the negotiation process. That is when she would do external market research to ensure she had the appropriate facts and figures to back up her request for a new salary or raise. She never undercuts herself because she knows the worth of the effort she will put into a job. Although, there have also been instances where Davida took a lower salary to get her foot in the door, even if she knew the position should pay more. But once she was inside, she made it a point to prove her value and get the highest increases and bonuses possible for her position. To her knowledge, she does not think any employer has ever offered her a lower salary because she is a woman or a woman of color.

Dr. Tana M. Session
Copyright 2020
Working While Black: A Woman's Guide To Stop Being the Best Kept Secret

Her advice when negotiating is, whether it is for a new job or an increase, do not give your answer right away. Let the hiring manager, recruiter or your manager know you appreciate the offer – or the raise – but you want time to think about it and come back to discuss it the next day. However, if the offer or raise is more than you expected, accept it IMMEDIATELY! She sees that as a sign they want you more than you want them, which works in your favor because you will already be ahead in the compensation game.

Reporting to Another Black Woman

Davida has never reported to another woman of color and, in most cases, has been the highest-ranking woman of color at her company. She has heard horror stories from other women about their personal experiences, and has made it a point throughout her career to mentor other young women of color. She has had the opportunity to be a featured keynote speaker at various industry events, both domestically and internationally. She sees those as opportunities to represent women of color in a positive light, especially in the White male-dominated field of finance and payroll. She knows some Black women in leadership positions do not reach back and help the next woman, but she feels that comes from insecurity and imposter syndrome.

Because she is so confident in her space and does not feel threatened by anyone, male or female, Black or White, she does not hesitate to share her knowledge and coach or

171

mentor other women. In mentoring other women who report to other women of color, she advises them to learn how to manage up in a way that changes how their manager treats them and speaks to them. She tells them sometimes they have to hold up a mirror to the other woman to see how she is showing up in the workplace and have a candid conversation with her about how she is being perceived by her direct reports, colleagues and peers. If that does not work, she tells them to plan their exit strategy.

Mentors/Sponsors/Advocates

Davida's first mentor was a 32-year-old White former model named Robin, who worked for the record store chain. She got her first corporate job early in her career. At the time, she did not know what a mentor was, but Robin plucked her out of the retail side of the business and positioned her to move over to the corporate side of the company. Davida had no idea who Robin was or that she was watching her. Robin had visibility into the retail level and knew the key players. She provided Davida with feedback and was a resource for her as she started to grow her career in the company. They still keep in touch with each other today. Like Davida, her mentor has since moved on to other companies and has grown her career while fighting breast cancer. In hindsight, not only does Davida see Robin as a mentor, but she also sees her as a hero and has a renewed appreciation for her strength and tenacity to make her mark in a male-dominated industry.

Another mentor is Kimberly Davis, who is currently the head of diversity for the National Hockey League (NHL). Davida first met Kimberly through an employee who reported to her. At the time, Kimberly was the only Black managing director at JPMorgan Chase. Although Kimberly does not recognize their relationship as mentor-mentee, but rather two powerful Black women supporting each other, Davida does not hesitate to tap into Kimberly for guidance and support.

Over the years, women have also approached Davida aksing her to be their mentor. Her initial response is to suggest they start a relationship first and see how it grows between them from there. She feels developing a mentor-mentee relationship should happen organically, and both parties should be able to learn from each other and gain from the relationship. It should not be a one-sided relationship.

Being the "Only One"

In her current role, Davida is the first Black executive in the 40-year history of her company. She does not take her position lightly and understands the level of responsibility that comes with being the first Black executive and the first Black female executive. She has a great relationship with her boss, the CEO, and does not feel any unnecessary pressure from the executive team. She has been welcomed with open arms. But she understands what she represents for the other Black female employees at the company and within her industry, which is predominantly White and male-dominated. In many

ways, she is a true unicorn in the financial space, especially in Hollywood. She is still the minority in her industry, and often when she shows up at industry meetings, events or conferences, she is one of a few who look like her.

Davida is now on a mission to teach others about her industry and profession to encourage other people of color to build careers in the field. She has not been able to wrap her head around the fact there are so many people of color on television shows and in the movies, but few of them at the executive level working for the studios or production companies. She feels an obligation to contribute to driving that change and seeing an increase in diversity at the industry meetings, conferences and events she attends in the future.

She understands the responsibility and the pressure of being the "only one." On the one hand, other people of color look to her to help them get ahead in their careers. On the other hand, she does not want to make any mistakes that may negatively impact the likelihood of others who look like her from having the same opportunities. She admits she does not know if that pressure is self-imposed, but it feels real to her every day. She firmly stands on the fact she is a Black woman first and an executive second, but she does not lead with that. She leads with her knowledge and expertise and lets her work speak for itself, after which the fact she is a Black woman seems to fade into the background for others.

Davida feels she struggles more with being a woman in her field than with being Black. Because of her name's

spelling, people often assume it was misspelled and list her name as David on conference agendas and name badges. White men tend to look past her, expecting to meet a White man named David Lara. She has witnessed their look of surprise when she would introduce herself and inform them her name was spelled incorrectly (David vs. Davida). She once had a co-panelist tell her he read her bio before coming to the conference but never saw her picture. After meeting her, he told her he had to reread her bio. This was an obvious example of a microaggression because he found it difficult to believe the person he was on the panel with was the same person whose bio he read before agreeing to be on the panel with her. Davida took it as a compliment and knew she left an impression with him, which would hopefully change his perspective about women of color in the future—do not underestimate them.

What Would You Change?

Davida has no regrets. She believes everything she went through was intentional and served a purpose. Of course, being molested and feeling helpless is one of the things she would definitely change about her life experience. In hindsight, Davida wonders if she would be the person she is today if that did not happen to her or if she had not made any of her choices along the way. At the end of the day, she cannot attest to whether these negative things contributed to her success, but they damn well did not exclude her from being successful!

Dr. Tana M. Session
Copyright 2020
Working While Black: A Woman's Guide To Stop Being the Best Kept Secret

Own Your Destiny: Davida's Advice

Own your truth! Own your truth! Do not hide from it! Take the good and the bad and mix it together. Understand it all serves a purpose and appreciate it for what it is; then, move forward with your life. Also, do not be afraid to learn, no matter how far up the totem pole you climb. Surround yourself with people who know more than you, so you do not become complacent. The most important thing for any young woman is to be cool with the person you look at it in that mirror and love the hell out of her, because then you will not let her fail. Davida advises you will never be able to get to where she is, neither personally nor professionally, until you feel as good about you as she feels about herself—and she feels GREAT! Most importantly, have fun with your journey and learn to enjoy all of it.

Dr. Tana M. Session
Copyright 2020
Working While Black: A Woman's Guide To Stop Being the Best Kept Secret

Danette Trosclair:
Senior Vice President

Danette Trosclair is the Senior Vice President of TV Production/Finance for Skydance Media. She has been a Senior Vice President for the last five years of her career and was formerly employed by BBC Worldwide and ABC/Disney. As one of the few Black women in finance within the entertainment business, she has experienced her fair share of challenges through discrimination, inequality, intersectionality and being the "only one."

Danette's path to success started with her attendance at Hampton University. She was a business major and had to take accounting classes and excelled because it came so easily to her. At the time, she had no idea what she wanted to do long-term. Her professor, Mr. V., pulled her aside and asked if she ever thought about accounting as a career. He recommended she switch majors because, as an accounting major, she would always have a job and career path. She eventually interned at JP Morgan and went on to land a job at Ernst & Young, where she handled auditing and became a Certified Professional Accountant (CPA). Following her position at Ernst & Young, she joined Warner Brothers, where she could combine her financial expertise with entertainment. She set her sights on

177

becoming an entertainment and finance partner because **entertainment** was "sexy," and finance was not!

Danette counts herself lucky when it comes to the support of her parents. She admits she grew up well and was sheltered from many of the troubles and dangers her counterparts experienced. Her father was one of 15 brothers and sisters who grew up poor and had to pick cotton in Texas; and her mother was one of 5 siblings who grew up fairly decent in Kansas City. They made certain their own children did not want for anything. Her parents emphasized the power of a solid education and the importance of not giving up, even in the face of adversities. They also believed in the mantra of "working twice as hard" and going the extra mile.

Her parents were always there to bail her and her siblings out of any difficulties, even as adults. She recalled a time years ago when she lost her home and had to tell her parents not to bail her out. She knew they are there if she ever needed them and was confident their own history of fighting for equality and fairness was their motivator for wanting to continue to help their children have a fair chance in life in any way possible.

From kindergarten to eighth grade, she attended predominately Black schools, but when she entered high school, it was her first real introduction to being around people who were not Black. It was a bit of a culture shock. She became a cheerleader because it was an all-Black cheer team. The high school was segregated, with the White students on

Dr. Tana M. Session
Copyright 2020
Working While Black: A Woman's Guide To Stop Being the Best Kept Secret

one side of the football field and the Black students on the opposite side. In some ways, the experience was familiar to her prior schools because she really did not socialize with the White students. After high school, she attended Hampton University, a historically Black college/university, where again she was among familiar people and behaviors, with little to no exposure to discrimination or inequality based on her race or ethnicity.

However, when Danette entered corporate America, she recalls being "bitch-slapped" with a dose of reality. She had to learn how to unwind her sheltered and privileged mindset to survive. The people who were her coworkers were snakes and wanted her job. There was discrimination, inequality, a lack of diversity and inclusion, backstabbing and jealousy. She quickly realized she had to maintain the same mantra her parents instilled in her just to prove she deserved to be in the position she was hired to do, working twice as hard and going the extra mile. Although exhausting, and at times unfair, she stayed the course.

Danette recalls her time at the Los Angeles-based Ernst & Young office, which coincided with the O.J. Simpson trial. She was a staff accountant at the time and studying for her CPA exam. She was the only Black person on a team of six who was assigned to a client engagement project. The team members would have open and candid conversations about the trial and state how they were convinced O.J. committed the murders. Danette never engaged in the conversations because she was

179

heads-down on project work and had not kept up with the trial. More importantly, she did not think she should comment since she was the only Black person on the team.

When the not guilty verdict was announced, the team watched the news, and a White woman on the team asked Danette if she thought O.J. committed the murders. She responded by saying she honestly did not know for sure since she had not watched the trial because she was too busy working. The woman immediately turned red in the face and responded by stating anyone who thinks O.J. did not commit the murders is stupid. Danette did not believe O.J. committed the crimes at the time, and she felt her colleague was calling her stupid in a passive-aggressive manner. She was fresh out of college and did not have the tools to understand how to work with difficult people, so she opted not to respond.

Immediately following the trial, her duties were reduced to making copies from eight in the morning until eight in the evening sometimes. She remained at the copier for days following the trial, and she felt her team and management was making her pay for O.J. winning his trial. This was the first time in her professional career that Danette realized there was a divide between Black and White coworkers. Up to that point, her coworkers had not been so overt with their beliefs and discrimination. She stopped being invited out for after-work drinks and was no longer assigned to prime projects. Her experience, work ethic and the fact she was studying for the CPA exam were being overlooked. She realized she

Dr. Tana M. Session
Copyright 2020
Working While Black: A Woman's Guide To Stop Being the Best Kept Secret

needed to leave Ernst & Young and look for new opportunities elsewhere.

Danette admits she never learned how to navigate corporate America. She had difficulty hiding her expressions and not reacting when people said or did something stupid or offensive. Early in her career, she was described as having a "chip" on her shoulder on her performance reviews. Before finding a mentor later in her career, Danette took personal development courses, which she paid for herself, to help gain skills to grow personally and professionally. Eventually, she found a mentor who provided guidance and insight on how to navigate as a Black woman in corporate America.

Audrey Stevenson hired Danette to work at Direct TV. She was a Black woman in a leadership position at a major company and unapologetic about hiring Black people. As a result of her setting that example, Danette has been the same way throughout her career. Besides Danette, Audrey also hired another Black man, and the three of them were an all-Black team and the only Blacks that sat on their floor. Audrey was tough on Danette, and at times she thought Audrey was being a bitch, but looking back, she can appreciate the lessons. Audrey taught Danette how to pick her battles, because not every one of them was worth trying to win. Danette also learned to take a step back, sit in the cut and observe before reacting or addressing an issue. It was about taking the beating, going home and sleeping on it. If a situation at work kept her up at night, then she knew she needed to address it.

If it did not seem to bother her the next day, she learned to let it go. She would draft email responses but not send them, just to release her feelings so she could move on.

These were all lessons she learned under Audrey's mentorship. She also learned how to be confident in a room because she saw this as an area Audrey frequently fell short in. She witnessed Audrey being attacked in meetings and saw her lack of confidence, making it easier for her to be picked apart by her boss and peers. Danette learned how to handle a room after watching those exchanges with her boss. She thanks Audrey to this day for hiring her and believing in her. She knows she would not be where she is now if Audrey had not taken a chance with her.

Danette eventually moved on to work for ABC. During her time there, she noticed a lack of diversity in the internship program and volunteered to take on a more active role. Eventually, she oversaw the finance and accounting internship program for the East and West Coast. Danette had to present her ideas on making the program more diverse and inclusive to upper management and remembers a particular encounter with one of the senior leaders, a White man by the name of Matt. He was adamant that he did not see the need for a diverse internship program. He felt it was a push for affirmative action. His idea for inclusion or diversity was hiring someone who had a degree in technology instead of finance or economics, but the interns he wanted to hire looked like him. Matt met her with force with every step of her internship

Dr. Tana M. Session
Copyright 2020
Working While Black: A Woman's Guide To Stop Being the Best Kept Secret

program initiative, making it difficult for any people of color to be hired as interns in his department.

The diverse interns who were hired all reported to Danette how horrible it was working for him. Matt did not believe in the diversity and inclusion initiative and felt it was a handout to people of color who were not qualified for the job. In spite of Matt's lack of support and being hard to deal with, Danette was able to develop a successful program, and five of the interns she hired there went on to work for Disney, where they each still have thriving careers in leadership positions. They still reach out to her now and then to run a question by her, gain her perspective or bounce ideas off her before presenting them to their managers.

Danette shares her struggles in corporate America with the young Black people she has hired over the years to help provide them with the tools and strategies she lacked early in her career. Some may classify her as being hard on them, but she does it out of a desire for them to be prepared for what is coming as they grow in their careers. As a mentor herself now, she helps her mentees understand why her expectations are high for them. They should never sell themselves short, and they must develop critical thinking skills and be solutions-based when faced with problems in the workplace. She would never assign them a project or task she felt they do not have the skills or knowledge to complete, but sometimes they will have to dig deep. She understands that the performance of Blacks tends to be watched more closely than their White

Dr. Tana M. Session
Copyright 2020
Working While Black: A Woman's Guide To Stop Being the Best Kept Secret

counterparts—meaning there is far less room for mistakes, and they do not have the luxury of relaxing or slacking off.

Danette makes a point of seeking new young Black professionals, whether in the workplace, industry outings, mixers or other networking events. She invites them to meet with her and understand they have a champion on their side in her mentorship. She remembers what it was like to be the "only one" and feeling like you do not fit in, and she wants to ensure others do not have to go through that alone.

There are other times when Danette experienced inequality and discrimination along her career path. She considers her time at ABC as the best and worst times of her career. Some of her fondest memories were when she found a sponsor in her boss, Jim, a White man. He took a personal interest in her success, and under his leadership, she got promoted from consultant to manager to director and eventually executive director. Over the years, she and Jim learned they had a lot in common and many similarities. He invested the time to get to know her as a *person*, and their friendship continues today with an annual Christmas dinner and time to catch up on each other's lives.

Her experience with Matt and others was not as favorable. Eventually, there was a shift in power and the CFO was terminated, and two other Black male employees had their positions eliminated. She was the only Black employee left on the finance team. Her career was stalling, and the bar for success and promotions kept getting raised higher. She also

started noticing she was no longer invited to certain meetings, resulting in her learning about things after the fact, which impacted her position.

She also recalls an instance when she saw a group of Black employees gathered by the elevator having a conversation, and she approached them and told them they should break it up so others did not feel uncomfortable or wonder what they were up to. When they all looked around, they understood what she meant and dispersed. Since she was in a senior-level position, she understood how their gathering could be perceived by White leadership. She didn't want any of them to be on the radar with so many job eliminations and terminations happening at the company. After all, perception is reality in corporate America. People tend to make decisions that can impact someone's career first and ask questions later.

Danette also experienced coworkers, who she considered to be friends, suddenly pulling away from her. She was no longer part of the in-crowd. In fact, no one who was Black was part of that crowd. After 11 years with the company, she was faced with deciding if she would accept her circumstances and live in the box they had built around her until she retired, or if she would move on and seek opportunities elsewhere. Danette had three kids and was fortunate to work for ABC when they had a pension, so she had a big decision to make.

Eventually, she decided to take control of her career and went to work for the BBC network as a Senior Vice President but was offered a lower Vice President level salary. Although

Dr. Tana M. Session
Copyright 2020
Working While Black: A Woman's Guide To Stop Being the Best Kept Secret

the salary was higher than her compensation at ABC, she did not feel strong enough to push back or negotiate a senior-level salary when she accepted the offer. She knew she could do the job and instead negotiated a salary review within a year with a guaranteed substantial five-figure increase, which she received without hesitation.

Danette knows there is still much more work to be done before there is true equality in the workplace. Even at her current workplace, she is one of the few people of color in a management position, which feeds her intention of hiring more talented and qualified Black employees wherever she can.

Own Your Power

Danette has learned over the years how to own her power in the workplace. Before she learned and developed tools to navigate corporate America, she was at the mercy of her superiors. Being the "only one" who looked like she did used to be a challenge, and sometimes a disadvantage; for example, her time at Ernst & Young during the O.J. Simpson trial. She experienced this again when she was an adult student working towards her MBA at Pepperdine University. There were times when she was excluded from groups, and when she asked to join one because it was a requirement of the course, she was told the group was already full. She had to have the professor step in, get her assigned to a group and was then only asked to proofread or confirm references for group papers.

Dr. Tana M. Session
Copyright 2020
Working While Black: A Woman's Guide To Stop Being the Best Kept Secret

Danette thanks her age, intention and knowledge of her abilities as the strength for owning her power. She knows she is exactly where she is supposed to be in her career and no longer needs mantras or positive affirmations to pump her up. She is very comfortable in her skin and knows how to communicate with all people at all levels. She has learned to meet people where they are and speak up when she sees injustice taking place in the workplace, or people not being given a fair opportunity. She has the tools to have those difficult and candid conversations with people because of what she brings to the table. She has earned her colleagues and peers' respect and has enough credibility capital to own her seat at the table. Danette is comfortable telling someone when his or her perspective appears flawed without fear of retaliation. She has also reached a point where she knows if what she is experiencing is real or just a personal perspective. She can legitimately distinguish between fact and fiction and handle it accordingly.

She has been able to use her power to help others. As an example, at her current company, she strategically hired a Black man for a specific role. Over the course of his first year, she challenged him and made sure he was well-positioned for a promotion. She built her business case, along with his exceptional performance under her leadership, and was able to get him promoted to manager with a substantial five-figure increase.

Her advice to others to help them own their power is to not operate out of emotions. If you have a battle you want

Dr. Tana M. Session
Copyright 2020
Working While Black: A Woman's Guide To Stop Being the Best Kept Secret

to win, have a solid business case and present your point of view in a way for them to understand your position and in a way where they cannot say "No." However, you must also have enough professional maturity and established credibility to know when it is good to ask for what you want.

Own Your Truth

Danette has learned the benefits of sharing her truth with her mentees and other young Black professionals she has met throughout her career. Not only has it been freeing to be in a position to share her life lessons, but it has also been helpful to others along their path to success. When she was experiencing inequality and discrimination, she felt she was alone. She now shares her truth openly to help others know they are not alone and they do not have to suffer in silence the way she did. She also emphasizes the importance of building relationships, networking effectively and strategically, not burning bridges and having mentors and sponsors throughout their careers.

Own Your Worth

Over the years, Danette has learned how to negotiate on her own behalf and be her biggest advocate. Because her skill set is such a niche, there are few people for companies to select from for open positions. As a result, there have been times when she was contacted about new opportunities at other companies. She has been able to leverage those offers

Dr. Tana M. Session
Copyright 2020
Working While Black: A Woman's Guide To Stop Being the Best Kept Secret

to have a salary discussion with her manager, especially if she learned the market shifted. Her skills are more valuable than what she was currently being paid. She has received salary increases and contract extensions based on having that knowledge and knowing how to be timely and intentional with her requests.

She understands she is not beholden to one company because her value can be used in other places. Danette advises that you must be willing to walk away if your value is no longer appreciated and they are not willing to pay you fairly. She has learned to unapologetically advocated on her own behalf over the years, and it has worked in her favor each time. She advises all Black women to remain self-aware, never stop growing and surround themselves with people who look like you and are like-minded, whether they are current or former coworkers or friends from college. Develop and foster a strong community you can count on when things are going well and, more importantly, when they are not. At the end of the day, she wants other Black professional women to know things will always work out.

Mentors/Sponsors/Advocates

Although she did not realize it at the time, Audrey from Direct TV, her Black female boss, was Danette's first mentor. Looking back, she appreciates everything she learned from Audrey during the time they worked together. She still taps into some of those lessons and readily shares them with

others. Danette credits Audrey for giving her a start on her current career path because Audrey sought her out and took her under her wing.

Her biggest sponsor was Jim at ABC/Disney, her White male boss, whom she is still friends with today. He supported her growth and invested time in getting to know her on a personal level. She knew he had her back, which gave her the courage to take professional risks and challenge herself regularly. Jim encouraged her to apply for the Disney Executive Leadership Program, where she met another mentor, Jena, who was paired with her through the program. She also enrolled in the National Association of Minorities in Communications (NAMIC) mentorship program and was partnered with Natalie as her mentor. They found out they had a lot in common and were very compatible. She has relationships with both of these women, even though she has long since left the official mentorship programs.

Her current boss, Carol, is also incredibly supportive and a true advocate. Over the years, she has learned her primary role is to make her boss look good, and colleagues and peers are always sharing with her that Carol speaks so highly of her. Their relationship has been a natural progression over the past couple of years, and Danette is genuinely grateful to have a leader with such intelligence, wisdom and grit.

Being the "Only One"

Early in her career, Danette would go out for drinks after work with her White coworkers. She noticed whenever she

would pull out her debit card to pay for drinks, her coworkers would tell her not to worry about it, and they would pay with their green American Express card. After noticing this a few times, Danette applied for and received her own green American Express card. One evening, she pulled out her AmEx card to pay for drinks, and she felt a new level of respect from her coworkers. She realized she had leveled the playing field in that one area overnight and removed a barrier that separated her from the rest of the team. Something so simple that she had never been taught about made a difference in how she was treated as the only Black person on the team.

Over the years, Danette has learned how to navigate being the "only one," whether in school or corporate America. She had to develop an appreciation for sushi and kale salads so she would not be excluded from a lunch invite, especially since her opinion was never sought out when lunch was being planned. She learned how to "go along to get along" in most cases. Danette turned these occurrences into learning opportunities because she realized the people sitting around the table with her did not have the same experiences. She felt it was important to educate them while making it a safe space for them to ask questions and have teachable moments.

What Would You Change?

Looking back over the span of her successful career, Danette admits there are things she wishes she had done differently. First and foremost, she would have started

networking earlier in her career. She feels Black people do not network very well. Building a support system early on and a true community of people you trust and can go to in a safe space is essential. Early in her career, she failed to see past her current circumstance or position, so she did not make an effort to develop strategic relationships and alliances.

She did not start being intentional with her networking efforts until about ten years ago. Now, she makes an effort to get to know her manager's manager and that manager's manager, and people in other departments at various levels. These are initiatives she used to shy away from out of fear of being considered a "brown-noser" or worrying her manager might feel slighted and wonder what they were not providing her. But she has seen the benefit these relationships have created for her White counterparts and has now experienced them in her own career.

Own Your Destiny: Danette's Advice

Danette's advice to the next generation of young Black women entering corporate America is first, know your worth from the beginning. Do your research and come prepared to advocate on your own behalf. Read the book, *Nice Girls Don't Get the Corner Office* by Dr. Lois Frankel and take heed to her advice. Use your community to help guide you, share knowledge and support each other. Also, know that everyone in a higher position was at your level at some point in their

career. This mindset should give you some comfort in knowing you can reach that level or even higher one day, too.

Look for mentors and advocates early in your career. Be unapologetic about your skills, knowledge and abilities. Do not give people a reason to count you out. Ask the questions you want to ask because if you don't...someone else will. Arrive at work and to meetings early to avoid the Black people stereotype of always being late. Think past your current project or position, and think "big picture." Use critical thinking skills and be solutions-oriented. Go the extra mile and deliver what was asked of you, but slightly more. Give them what they did not even know they needed. Make your boss' job easier, and learn how to change your job description while in your current role...expand it! Create so much value in your current position so that when they have to replace you, the job description has to be rewritten because you have redefined what excellence looks like in that position. Get yourself a mantra or positive affirmation to help pump you up every day. Danette's mantra was, "I'm Black! I'm beautiful! I belong!" or stating, "You got this!" over and over to herself.

Finally, Danette also emphasizes the importance of maxing out your 401(k) contribution and obtaining an American Express card, so you fit in, but only use it for work purposes, like drinks with your coworkers after work or lunch!

Dr. Tana M. Session
Copyright 2020
Working While Black: A Woman's Guide To Stop Being the Best Kept Secret

Maxine Cain, CEO/Founder

Dr. Maxine Cain is the Founder & President of STEM Atlanta Women, Inc., founded in 2016, and COO/Co-founder of Inclusion, a tech start-up company founded in 2019, which is a human capital platform for freelancers. Prior to starting her own businesses and becoming a serial entrepreneur, she started her corporate career with a Fortune 50 company in 1994. By the end of her corporate career in 2015, she was a Senior Human Resources Manager responsible for business and government enterprise accounts.

When Maxine was a young girl, she wanted to be a judge but did not complete her college degree. Her plans shifted when she took the path of aviation and became a flight attendant, where she eventually became a manager of other flight attendants. She eventually got married, had children, and wanted to pursue a position with a long-term career path. She aimed her sights on a career in healthcare or telecommunications. She ultimately landed a position as a Customer Service Representative at a telecommunications company to learn about the field from the ground up. She knew she would eventually get back into a leadership role but wanted to first learn everything she could from her entry-level position. In less than two years, she was promoted to Supervisor

due to her demonstrated skills in employee relations and leadership. Since Maxine still had a secret desire to be a judge, she decided to pursue a career in Human Resources because it felt like a position of "judge and jury" to her at the time. She gained her entrance into the Human Resources department by volunteering for projects in the department in addition to her Customer Service Supervisor duties. Her first major project involved implementing an onsite day care center for call center employees. The goal was to reduce turnover and attendance issues with Customer Service staff.

Her first mentor at the company was a Black woman who was a Senior Director based in New Jersey. Maxine leaned on her mentor to help her understand Human Resources. She ultimately attended a company conference where all of the company-wide Human Resources leaders attended. Her mentor invited her and her other mentees back to her hotel room to spend some time answering their questions and giving them career advice. It also allowed her the opportunity to get to know her mentees on a personal level and in-person since they were not all located in New Jersey.

In 2000, there was a merger of the Human Resources organization as part of a joint venture staffing project. Her mentor was very influential in talking to another Human Resources Director, a white man, about Maxine's career goals. She was truly her sponsor and opened up the opportunity for her to join the Human Resources team. The Human Resources Director reached out to Maxine about a year later and told her

about an internal Human Resources Consultant position and encouraged her to apply for it. She was already working on the joint venture project and was assigned to a Human Resources Manager, another Black woman. Imposter syndrome soon kicked in, and she doubted her ability to be a fit for the newly created position. She felt she did not have enough HR experience and almost talked herself out of a position that was being handed to her. Her internal voice told her to apply for the position, which she did... and she got the job. She was the first person hired into the new HR business model and stayed in the role for a year before being promoted to HR Manager when her manager got promoted to HR Director. She went on to support five Call Centers and multiple Vice Presidents and Directors within the organization in her division.

During the course of Maxine's career, her marriage started falling apart. Her husband had been a computer engineer for a large international corporation when the "dotcom bubble" burst. He was laid off from his job and lost his identity in the process. It took him forever to find another opportunity, so he told her he wanted to start his own business instead of working for someone else. Maxine supported him, but the business idea did not work out, resulting in her being the breadwinner and supporting the family by herself, which eventually took a toll on their marriage. They went through individual and couple's therapy and tried everything to make it work. Maxine believed in the sanctity of marriage and had small children to think about. However, after years of trying,

Dr. Tana M. Session
Copyright 2020
Working While Black: A Woman's Guide To Stop Being the Best Kept Secret

in 2012, they got a divorce. Maxine admits she grew weary of wearing an "S" for Superwoman on her chest. She was trying to do it all while building her own career and raising her small children. She hit a wall and knew the marriage was no longer serving her.

Maxine eventually moved on to the business and government enterprise department, where she reported to a white woman who was married to a Black man. Her new manager was very supportive of her but eventually left the company, and a new white woman was hired to replace her. Maxine did not have the same supportive relationship with her new manager. By this time, she had been in the HR Manager role for 16 years with stellar performance and prided herself on the fact she never had any performance issues or write-ups during her entire career. However, she felt her new manager was intimidated by her and constantly questioned her work.

There was another Black female Vice President who ran their department. Maxine supported her and had been working with her on company-sponsored women's leadership conferences for 14 of her 16 years with the company. There was an issue with the final conference she worked on, which caught her completely off guard. The Vice President wanted to have a conference but did not have an approved budget. By the time Maxine found out there was no approved budget, she had already signed a contract with the hotel and various vendors, leaving the company on the hook for expenses that were never budgeted for but had to be paid. The conference

was canceled, and the Vice President and her immediate manager wrote her up and put her on a final warning, stating she was not authorized to sign any contracts on behalf of the company. Fortunately, Maxine maintained copious notes and had all of her documentation from her meetings and emails with the Vice President relating to her duties for organizing the conference. Maxine filed a complaint with the Equal Employment Opportunity Commission (EEOC), who conducted a thorough investigation and found no grounds for her to receive a final warning. None of the women around her supported her during the investigation, and most kept their distance, with the exception of her immediate boss, a fellow Black woman.

She won a settlement representative of the claim she filed. At this point, her employer was starting to do layoffs, and Maxine raised her hand to take a severance package, yielding her a six-figure payout on top of her EEOC settlement. Maxine took a year off and spent that time building out her first business enterprise, STEM Atlanta Women because she noticed there were not a lot of Black or Latina women in technology at her employer. She saw a problem and wanted to help fix it. She wanted to enhance and educate women and girls of color on the future of technology and increase their interests and awareness of opportunities in technology.

When she represented her company at college campus recruiting events, she realized there was minimal interest from women of color in their technology positions. She

started conducting focus groups and local various events and workshops to build awareness for disadvantaged people of color. She had experience dealing with community leaders, conducting corporate events, and recruiting on campus from her experience at her employer. So, she tapped into those transferable skills for her own company.

During her year off, Maxine was approached by a small occupational health company looking for a new Senior HR Director. Her savings were starting to run low, so she figured it would be a good opportunity to be part of a senior leadership team. She thought working for a small company with less than 200 employees would be a breeze compared to her previous HR responsibilities at the Fortune 50 organization. Shortly after joining the new company Maxine knew she had made a mistake. They had several HR Directors before her, and none of them stayed. There were sexual harassment claims and managers sleeping with frontline employees. All the while, the Medical Director/Founder felt he could do whatever he wanted to without recourse because his brother was the company's attorney. There was a white woman, the HR Leader, who interviewed her for the job, and after three months, she had a candid conversation with Maxine about the company. The Medical Director, who was a Black man, was not fond of Maxine. She did not comply with his behavior and would regularly challenge him about the company's activities after conducting thorough investigations trying to protect the young women who were working there. That same inner

Dr. Tana M. Session
Copyright 2020
Working While Black: A Woman's Guide To Stop Being the Best Kept Secret

voice from her early career came back and told her to quit after her first three months there, but she ended up staying for a year.

Fear gripped her because she had a daughter in college, was a single parent, and was running out of savings. She also felt she owed them at least a year and wanted to be professional and provide a three-week notice. She eventually wrote her letter of resignation but deleted it before submitting it. Two weeks later, she fell on the floor near the front entrance of the office and injured her right shoulder and knee. This happened on a Thursday, and she thought she was going to be fine. But by the next day and throughout the weekend, her pain got worse. While driving to work on the following Monday, she had to pull over on the side of the highway because the pain was so bad, she could no longer drive. She called an ambulance because of the excruciating pain and was taken to the hospital, diagnosed with severe contusions. She was out of work for a week trying to recover, and the Medical Director kept calling her asking when she would return to work and requesting her to work with their doctor and not the Worker's Compensation doctor, which was an obvious conflict. While she was still on bed rest, he notified her he decided to restructure the HR department, and her position would be eliminated. She was on Workers' Compensation and had to get an attorney involved, but after a year, she was able to get a small severance from the company. She left the company in 2018 and turned into a full-time serial entrepreneur.

Own Your Power

When Maxine was a teenager, her mother went through a divorce, and she had to help take care of her younger siblings. As a result, she only completed 3.5 years of college. During the course of her career in corporate America, she admits she has been made to feel inadequate for not having a degree. She is certain she did not get jobs that seemed like a perfect fit for her because she did not have a degree. She recalls one instance when she interviewed for a job and was denied based on the fact she had not completed her undergraduate degree. When she discussed the position with other people in the company, they confirmed a degree was not required for the position, and she had the necessary experience.

The hiring manager was a white woman who talked down to her throughout the entire interview. She eventually landed a position in the Human Resources department for that same company and eventually moved into the HR Manager role. During the course of her time in that position, she was faced with the task of terminating that same hiring manager for poor performance, bad workplace behavior, and discriminating against marginalized employees. Maxine admits it was difficult to fire her and not have a smile of vindication on her face as she delivered the news.

As a full-time entrepreneur, Maxine admits she has gone back and forth on whether to reenter the workforce. She is over 50 years old and knows ageism and discrimination exist. She remains prayerful and taps into her faith on a regular basis to

Dr. Tana M. Session
Copyright 2020
Working While Black: A Woman's Guide To Stop Being the Best Kept Secret

ask for guidance. She knows God has given her everything she needs to be successful and knows she is the "head and not the tail." Like a lot of entrepreneurs, she still battles with her own fear of the unknown but remains diligent and steadfast.

Maxine started her business with her own limited funds she gained after leaving her employer. She started her company as a non-profit and knew she would have to show proof of her work before asking for funding or donations. Black excellence was her intention, and she was deliberate about not asking for corporate dollars. Over the years, she has established proof of performance and has since secured corporate relationships with Zuckerberg Media, The Coca-Cola Company, Delta Air Lines, GE Digital, and Deloitte, to name a few.

Own Your Truth

Over the years, Maxine has suffered from imposter syndrome, but she has learned how to incorporate coping mechanisms to help her manage it. She has learned to leverage her influence and partnerships, which she classifies as her social capital, to help her through those moments of self-doubt. Maxine appreciates the importance of social capital and has been able to use it effectively to get anything she wants. She also teaches a class on the importance of social capital and collaboration to emerging leaders of color to help close the gap for them earlier in their careers than it took for her to learn on her own.

She has also incorporated the guidance and support of a self-awareness coach to help close any additional gaps in her personal and professional growth. Through her work with her coach, she has learned she has some innate belief systems she was raised with that have held her back in her career and her business. She is becoming more curious now, asking the right questions and seeking to understand more.

Maxine stands on her truth because she is solidly grounded in her faith and knows she will overcome any shortcomings she may still struggle with. She acknowledges the area she needs to improve, figures out the best way to overcome it, then works on the correct course to correct it. She will research, study and train to learn what she does not know, including reaching out to people in her personal network who have the expertise or knowledge she lacks. This is a strategy that has helped her many times in her corporate and entrepreneurial pursuits. Maxine surrounds herself with great curators who are experts in their space, which helps her understand she does not have to have all of the answers or know everything, but rather have the right people on the team or in the room.

Own Your Healing

Maxine remains in prayer, asking God to grant her wisdom, knowledge, and understanding every single day. She seeks guidance from Him, which helps keep her grounded in knowing who she is and how she is showing up in the world. Part of her healing came as a result of her workplace injury

Dr. Tana M. Session
Copyright 2020
Working While Black: A Woman's Guide To Stop Being the Best Kept Secret

at the occupational therapy organization. She was a person who made a lot of money throughout her career and was considered successful by those around her. Because of her shoulder injury, losing her job, and not being able to find another job immediately, she was faced with determining who she was in the world without the corporate job, salary, and title. She experienced significant frustration and bitterness while having to grind looking for a new job and eventually making her pivot onto the entrepreneurial path. She kept asking God, "Why Me?" and "What is going on?"

Maxine had been working since she was 15 years old and was quickly approaching her 55th birthday and wondered why she was going through this at this age and stage in her professional life. She had to deal with fear and pride. She had to readjust and shift her thinking and embrace the fact she still had so much to offer, even if companies could not appreciate her. She knew in order to be successful, you have to be broken, just as God broke bread to feed the multitudes. All of the millionaires in her personal network have experienced being broken at one point or more on their path to success. Maxine has also learned to embrace self-care as part of her healing process. Her advice is to learn to let go of the past in order to receive the gifts of your future.

Own Your Worth

The imposter syndrome definitely impacted Maxine's worth. Being made to feel inadequate because she did not

possess a college degree also impacted the value she placed on herself. Even though she had made a six-figure salary for over 15 years in her corporate career, she still had a feeling of self-doubt. Throughout her life, she has met people who held PhDs who still had not crested a six-figure salary, yet she still did not give herself enough credit or validation because she lacked the credentials of a college degree. She had to learn her value was not placed on having a degree but rather on the relationships she built and the experience she brings to every position, including entrepreneur. At this point in her life, obtaining a college degree would be purely a personal accomplishment and not necessary for her to continue to grow and be successful as an entrepreneur. However, she encourages the next generation to get their degree, so it will be one less obstacle to overcome in their pursuit of excellence and success. In 2020, Maxine received an honorary Ph.D. in Humane Letters, Humanitarianism – STEM Education & Training in recognition of all of her work in the STEM field, earning her the accolade of Dr. Maxine Cain!

Maxine also advises women to pay attention to their inner voice. If you get a sense, the company or position no longer serves you, start developing an exit plan to place you in the position or company that is right for you. She admits she stayed too long at the occupational health company for fear of losing a paycheck. As a result, she ended her career there with a severe workplace injury and job elimination. Looking back, she would have left there much sooner and started looking

for employment elsewhere with an organization more aligned with her career objectives, core values, and morals. Listen to your inner voice and do not let anyone tell you it is not real... it IS real!

Mentors/Sponsors/Advocates

Maxine believes in the power of mentorship. Through her organization, STEM Atlanta Women, she mentors young women and has incorporated other established women in Atlanta as mentors for the next generation. She counts Bobbie K. Sanford and Carolyn Young, wife of former Ambassador Andrew Young, as her personal mentors, among others. She actively seeks out other established women of color to mentor and develop the younger women in her organization. Maxine cannot understand the mindset of other women of color who have "made it" but do not see the importance of reaching back to mentor and support others behind them.

Her advice to women seeking a mentor is to carefully vet the person you are seeking to be your mentor. Make certain you have something in common with them and that they are the right fit. Do not just focus on their title or level of success. Also, approach the relationship authentically and organically. Be real and give just as much as you want to take from the relationship. Show up prepared for your meetings with your mentor. Have an agenda or specific questions or situations you want or need help with to get the most out of your time together.

206

Being the "Only One"

Although Maxine has not personally experienced being the only woman or only Black woman on her team, she has dedicated her work for STEM Atlanta Women to preparing the next generation with tools on how to navigate this likelihood effectively. She has been fortunate to have companies reach out to her proactively to seek advice on what they can do better as it relates to effectively recruiting for inclusion and diversity. She uses these requests as opportunities to represent the next generation to ensure future workplaces are truly designed for their success. She admits she does not come across a significant number of women of color at the senior levels in technology, which is what drives her passion for the work she does now.

Own Your Destiny: Maxine's Advice

What are you most passionate about? What do you want to be known for? What if God were to ask you, *"What do you want to do,"* or tells you: *"You can do whatever you want"*? What if He asked you to tell Him what YOU want... and it will be yours? What would you tell Him? She reminds women to remember God is the ultimate coach. He calls the plays, and we run them.

Often, when Maxine asks those questions to women, they are usually stumped. She wants women to understand God wants them to be successful. All you have to do is ask. Maxine is a firm believer that it is so important to figure out who you are first, so you have a clear path for your "Why." You have to

be clear about who you are and what you want to do, then establish the correct strategies and solutions to get you there. Doing your research and seeking personal and professional development is key. Perhaps even finding a coach who can help you and hold you accountable along the way. She wants Black women to know nothing is stopping them because God has already given them everything they need to succeed. Look within yourself and know you are already gifted and equipped!

Maxine also believes it is important to learn to trust and believe all things are going to work out for the greater good without having to worry so much. The birds and animals never worry about how things will work out for them—it always does. God looks out for them, so why would he not look out for us. We have His favor. Maxine feels everyone should learn to embrace that same mindset. Every day Maxine has a simple prayer where she asks God for fresh, new mercies and supernatural, abundant, unprecedented, unmerited, and distinctive favor every day. She is confident it works in her daily life.

She also stresses the importance of social capital and collaboration. The wealthiest people in the world value social capital the most because they can pick up the phone, make something happen without paying a penny for it, or gain access to a room they desire to enter. Social capital is golden and worth more than money, so start creating yours sooner rather than later, and definitely before you need it.

Karen Nelson – Diversity & Inclusion Leader

Karen has been the Diversity & Inclusion Leader for the City of Appleton, Wisconsin for three years. However, in 1994, she created her Leadership and Diversity consulting firm. As she has learned over the years, it is essential to have your own business in parallel with having a 9-to-5 whenever possible. Although she is not currently running any projects through her organization, she still owns it and maintains an online presence.

Karen's path to her current position was not a direct one and actually started in the Science, Technology, Engineering & Mathematics/Medicine (S.T.E.M.) field. She is a scientist at heart and started her career as a bench chemist. She found her way into the world and the space of diversity and inclusion quite accidentally just by living her life and showing up as her authentic self. She admits she is very fortunate to have come from a comfortable, Black middle-class background. She never wanted for anything and had very supportive parents. She is the middle child and only girl out of four children. Her parents constantly told her and her brothers they could be anything they wanted to be—and they listened. They are all college-educated, two with doctoral degrees and two with masters' degrees.

Dr. Tana M. Session
Copyright 2020
Working While Black: A Woman's Guide To Stop Being the Best Kept Secret

She first gained an interest in science when her two older brothers, who are doctors now, received a chemistry set on each of their 10th birthdays. When it was her 10th birthday, her parents had a decision to make. Do they buy her a Barbie doll or a chemistry set like her older brothers received, and her younger brother would also surely receive one day as well? Although she DID get a chemistry set that year, they opted to also get her an Easy Bake® oven to her parents' credit. These gifts led her down her path of chemistry, resulting in her becoming an award-winning formulator.

Karen excelled in math and science in high school and received a full scholarship from the National Science Foundation to attend Bennett College in Greensboro, North Carolina. She graduated college in three years and was the first person out of her graduating class to land a real job, which was in the research facility of a cosmetic manufacturing company based in Cincinnati, Ohio. She was excited about her new job and loved it. Karen felt she had lived a storybook Black girl's life growing up and was now doing the same as a young lady. Her parents had always encouraged her to not only be what she wanted to be, but to also speak her mind... but do it with respect and a little southern charm.

When she arrived in Ohio, she was a newlywed, a new graduate at the top of her class, full of confidence and unapologetically Black, even before that term was popularized. One Monday morning, she walked into her section head's office, who was a White man. She announced she wanted

Dr. Tana M. Session
Copyright 2020
Working While Black: A Woman's Guide To Stop Being the Best Kept Secret

to tweak some of their formulations so she could make recommendations for the company to enter the ethnic hair care business. She was told that would never happen and she should go home. Instead of getting angry, she decided to do some research. She returned to her manager with articles and copies of *Essence* and *Ebony* magazines to show how viable the ethnic hair care market was becoming. She even included information about Madam C.J. Walker to help describe and authenticate the emerging market of Black hair care as well as her formulary ideas. Her manager told her as long as he was at the company, her initiative would never happen. He disregarded all of her research and documentation. He was a very highly respected section head and had longevity, so she knew she was fighting an uphill battle with him.

Karen was the only Black female chemist and the only Black person on the company's scientific research team in that department. When they had team meetings, she would make recommendations that had nothing to do with her ethnic hair proposa. However, she was ignored, felt that she wasn't heard and other people would talk over her. When she made a good recommendation that the team liked, her manager would ignore her, but then a White colleague in the same meeting would make the same recommendation differently, and suddenly it was regarded as the greatest idea! People treated her as if she were invisible. She recognizes now that these were all microaggressions, but she didn't have a name for it at the time.

She would go home to her husband and cry and try to figure out what she was doing wrong. She started having periods of self-doubt. She felt marginalized when her ideas were being ignored or only accepted when given by her White coworkers. She knew she would not be successful under her current manager and started to realize how true the saying is, "Employees don't quit their company; they quit their manager." This propelled her interest to seek other avenues for her career where she would be accepted for who she was in totality and have her ideas heard and embraced. It led her to her first career move, which was a transition to the marketing side of the business.

Her formulation duties as a chemist allowed her to sit in on the marketing team meetings. In her role as the chemist, she was responsible for helping substantiate claims made by the marketing team, so she was a key contributor in those meetings. There were more women in those meetings as well as liberal and creative advertising team members from New York. It was a whole new world on the marketing side of the business, so she made the switch. She had a voice and worked with people who wanted to hear her ideas. She made a name for herself and stayed in marketing for 12 years before moving on to other opportunities.

Karen ended up in Wisconsin, where she became the first African-American Corporate Diversity Manager for General Electric Medical Systems. Through her community service and involvement with the NAACP, she gained a lot of visibility and

Dr. Tana M. Session
Copyright 2020
Working While Black: A Woman's Guide To Stop Being the Best Kept Secret

notoriety locally. When the time came for the first diversity position to be created, her name was mentioned multiple times to the hiring manager. At the time, she was in the marketing department and had a reputation of having a "loudmouth," but in a good way. She spoke up and did not hide who she was or how she showed up. She ended up overseeing the diversity program for the United States, Latin America and Canada.

Karen credits her strong faith and loving husband as her two 'go-to' weapons in facing adversity. Raised in a conservative Christian home, Karen had a somewhat storybook childhood with great parents living a Black middle-class life and did not face any adversities at home or in her all Black schools. She grew up in the segregated South during the Civil Rights era. The signs of "Whites Only" and "Colored" were down, but the practices continued. Her parents took the family to the rallies when Dr. Martin Luther King, Jr. spoke at the historic Morris Brown A.M.E. Church, so they learned the art of nonviolent protest at an early age. This was fundamental to channeling her passion for social justice. She eventually married her high school sweetheart in that same church at Morris Brown (his family's church), where she heard Dr. King speak when she was a little girl. They are still married today, recently celebrating their 40th anniversary. They have two adult children, a daughter and a son.

Looking back, she feels confident her adversities struck after she entered the workforce. A newlywed at the same time when she entered the workforce, she credits her husband for

being her backbone through it all. She came to realize it was not any particular department that made her feel marginalized and unaccepted, but rather individual people that truly make the difference in one's experience. Later in her career, there were other meetings she would sit in and be marginalized or made to feel invisible, but she was even more emboldened based on her previous experience. She would speak up faster and harder, of course, in a non-confrontational and respectful manner, but still get her point across and have her voice heard. She pulled from her experience growing up during the Civil Rights era, her husband's support and her years of service with the NAACP to cope with how she was treated in the workplace by her White counterparts. She knew how to handle them and still be productive in a nonviolent way without displaying the "Angry Black Woman" syndrome. But she realized she was taking those contained feelings home and displaying the angry Black woman to her husband, which was not a good thing and was not fair to him. However, the home was a safe space for her to release instead of doing so at work.

Her husband created that safe space at home, often greeting her with a single red rose that became his signature from their dating years, which he still does now. He has been by her side every step of the way. He encouraged her to start her consulting company, NelStar Enterprises. In fact, he named the company a hybrid of their last name—Nel and the Star, because he always told her that she's a *star*. He taught

her about contracts and the art of negotiations. He is her Superman, known to many as *SuperStan-the-Man*! He was, and is, the listening ear and sounding board, always being there for her through every career change and every adversity.

Karen also feels certain her income has been negatively impacted, purely because she is a Black woman. She feels she would be further ahead financially if she had been paid fairly and equitably at the beginning of her career. She recalls wearing $.50 lapel buttons in recognition of the time when women only made $.50 for every dollar a man made. That number is just over $.80 for White women and just over $.60 for Black women today. Human Resource departments found ways to rationalize salary decisions in creative ways since they can no longer say a man should earn more because he has a family to take care of. She is well aware of the data and knows she has been a product of disparity and inequality.

During one point in her career, when Karen left Wisconsin to pursue another role as the first Corporate Diversity Manager for a company located in Dalton, Georgia, the Great Recession of 2008 hit. She was the highest-ranking African-American woman at the company and was impacted by the reduction in force. At first, the company looked at natural attrition, such as retirements, and they offered packages to people who left voluntarily. Karen was part of those initial employee meetings and discussions but eventually was excluded when the meetings pinpointed her job.

Dr. Tana M. Session
Copyright 2020
Working While Black: A Woman's Guide To Stop Being the Best Kept Secret

Then one day, about a year later, her manager approached her and told her the company had no more fat to trim and "we're now trimming bone," and as a result, she was being let go. Although the move was part of the overall continuum of the forced reduction, and she was given a generous separation package, the fact that she was the highest-ranking woman of color and the first and only one handling diversity for the company left room for doubt as to why her position was eliminated. Fortunately, she maintained her consulting company during that time and fell back on it, and quickly established a new book of business.

She eventually returned to Wisconsin and enrolled in the University of Wisconsin in Milwaukee to obtain her Executive MBA. Upon graduation, while she was sitting in her career advisor's office, she came across the opening for the Diversity & Inclusion Leader for the City of Appleton. She graduated in May, interviewed in June and started in her new role in July. And for the first time in her career, she would not be the first one in the D&I role but rather the seventh person to hold that position with the city. The Mayor, Tim Hannah, was first elected the same year Bill Clinton became President.

He ran on a platform of including racial equality at a time when Appleton was 97% White. He was open to creating the position when presented to him by the Appleton Police Chief in partnership with Appleton Area School District Superintendent. Both saw the population changing with the increase of the Hmong population in the city, which initially

started with a refugee movement following the Vietnam War. Over time, the Hispanic and African-American communities began increasing as well. Hanna was ahead of his time and believed in being proactive and not reactive, which is why he created the D&I position back in 1997. He is now in his sixth term. In her role, Karen gets to represent the Mayor at various community events for each diverse culture that now calls Appleton home and makes up 15% of the population, versus the 3% when he was first elected.

Own Your Power

If you are familiar with Maslow's Hierarchy of Needs, Karen lives her life at the very peak of the pyramid, which is self-actualization. She is comforted by the fact that she can be who she is in her authentic way. Karen is 100% comfortable in her own skin. She feels there is nothing better than being able to open her mouth and say what she has to say and know that she is in a position as a leader in the room where people are able to not only listen to her words, but also act upon them.

Karen recalls an incident where she was invited to a meeting to discuss a topic that would greatly impact the Asian community of Appleton. When she looked around the room, she noticed there were no Asian-Americans included in the meeting. She immediately spoke up and said there was no way there should be a meeting to discuss issues in the Asian community without having anyone from the Asian community represented. She recalled her ethnocentric decision-making

course from her executive MBA program and knew this was wrong. If you are in a room of all White people who are making decisions about something that will impact an ethnic community without having their representation at the table, then they are making an ethnocentric decision when they are not a part of the ethnic group being impacted. That is the epitome of White privilege, when they think they know what is best for another ethnic group. She provided the names of women she knew who should be included in the next meeting. She was able to use her power of her position of being seated at the table to invite others who would potentially be impacted by the decisions being made at the meeting to join the table. She now uses her power to help others in a way that was unavailable to her earlier in her career. Her advice when it comes to owning your power is not to be afraid but to be courageous.

Own Your Truth

Karen walks through life with a high level of confidence. She wakes up at 4 a.m. through the week to pray for strength and listens to gospel music that grounds her each day. She recognizes that being a highly confident Black Woman may disarm many people while, at the same time, be admired by others. She works hard to ensure her confidence is not viewed as cocky and tries to be as down-to-earth and approachable as possible. She speaks to a janitor the same way she speaks to a CEO. Due to her experience earlier in her career, she no

longer allows people to marginalize her. She has found a way to put people in their place and call them out on unacceptable behavior in a diplomatic but firm way that is fact-based and not based on emotions. Putting these actions into practice each day has helped her own her truth.

Own Your Healing

One area of Karen's life that still stands out to her is that she left her scientific career behind, which still hurts her in some ways. She had a conversation with her son and daughter one day about their different career paths. Her daughter is a public health attorney director with undergraduate degrees in biology and political science and a law degree. The topic of S.T.E.M. came up as they were celebrating a milestone in her daughter's career, and her son (an IT Professional) asked her if she could imagine how much more successful she would be if she had stuck to her career in chemistry. He went on to say he believed she would have several patents by now and would have created so many new products. He said he believed she would be Vice President of a Research & Development department by now...making a lot more money, as opposed to being in Diversity & Inclusion. That comment conjured up a bit of regret and reflection for Karen, but she does not spend time or energy on "what if" scenarios. Going through that career change and accepting her success in her current role has been a form of healing for her. All the more reason to help young women pursue their S.T.E.M. careers!

Another area Karen had to heal from, following the Great Recession of 2008, was being laid off from her job in 2009 in Dalton, Georgia. Before the recession, she was enjoying a successful career and was financially stable with a six-figure income. They moved into a mini-mansion in Georgia and were the first Black family in the neighborhood. This was an outward sign of their success. Even members of her church looked up to them as a representation of what is possible for Black people. After being laid off, they lost their home while she tried to rebuild her consulting business, which was off to a slow start. In the meantime, she got an excellent opportunity to join AmeriCorps. She became one of the most successful licensed representatives enrolling people into the new Affordable Care Act medical coverage program. Humbly working well below her former salary, she found the fortitude to keep going in the face of great loss. Karen hung on to the words of Dr. Martin Luther King, Jr. when he emphasized, "it does not matter if you are a street sweeper, you should be the best street sweeper out there." She earned multiple awards and recognition for her work, enrolling people of all ethnicities from urban to rural communities into the coverage program. She regained her confidence to pursue an opportunity in the corporate setting again.

However, for the first time in her career, she was declined for several of jobs because she did not have a Master's degree. After searching for programs to enroll in, she decided to attend the University of Wisconsin Milwaukee's Lubar School

of Business because of the international residency program to strengthen her global worldview. While working for AmeriCorps, she earned a scholarship and applied it towards her tuition, and she and her family returned to Wisconsin to start their lives over. Karen says it was the best move she ever made in her personal and professional life. It helped her heal through the impact the 2008 recession had on her and her family.

Own Your Worth

Karen recognizes her current position should be at the Director level. Due to the political component of approving position titles and salaries, her Director title has not been officially approved, although she does Director-level work. However, she did not let that stop her from negotiating a salary she felt was fair and equitable. She did her research and knew what she should go to the negotiation table requesting, so it was an easy conversation. The Mayor approved what she asked for, so not having the Director title has had little to no impact on her worth. She acknowledges that doing your research in advance of negotiations and asking for what you want are the first steps to owning your worth. At the end of the day, all a hiring manager can do is say, "No," which will let you know where they stand. But at least you were prepared and took the initiative to ask for what you want and deserve.

Karen advises of another component to owning your worth, which is relationship building. When you start a new

Dr. Tana M. Session
Copyright 2020
Working While Black: A Woman's Guide To Stop Being the Best Kept Secret

job, you are the new kid on the block or the *new shiny thing* in the office. You will be under a glowing light for a while until the next new kid on the block arrives. Use this time as an opportunity to build relationships with key stakeholders early in your new position while you are being embraced and actively on their radar. Internal relationship capital is invaluable...it can make or break your career!

Reporting To Another Black Woman

At a point in her career, Karen worked for a company based in Atlanta. She could not wait to work for a Black-owned company where she had the opportunity to work for the Vice President of Marketing. The woman she worked for was of Jamaican descent and was a former beauty queen. She was gorgeous and intelligent. Karen was in awe of her and loved working for her. She learned a lot from her but did not feel supported. At the time, she could not determine if this was a cultural issue or the epitome of the syndrome of Blacks not supporting each other in the workplace. Either way, Karen felt like her manager was always on her back about something.

Karen went from totally admiring her to realizing the relationship was not going to work. Her manager was difficult and criticized everything she did. By the end of their time together, Karen knew she could not work for her any longer. She had already experienced working for a problematic White male manager at the cosmetic company and was determined not to put herself through that again. Karen knew this behavior

222

was unacceptable, especially from another Black woman. She made a promise to herself that if and when she ever had the luxury of managing another woman of color, she would not be that type of manager.

Owning her own company, Karen has had the opportunity to hire other women of color, including her Executive Assistant. While working together, Karen encouraged her to go back to school and finish her degree, and she continually uplifted her. Karen wants her legacy to be one of always leaving the space and people better than you found them.

Mentors/Sponsors/Advocates

Next to her husband as her number one supporter, Karen credits one of her mentors, a Black man, for helping her secure her current position. Her position was vacant for a year, and the Human Resources team presented several candidates to the Mayor. He had a vision for the person he wanted in the role and did not mind keeping it vacant until they located "the right" someone. During that year, the city council questioned the Mayor if the position was still necessary since it was vacant for such a long period. They wanted to reallocate the budget for the approved salary for the position to other community initiatives.

But the Mayor and the community were adamant the position would be filled with the right person. Her mentor was well-known in the community, and the Mayor was fond of him as well. When Karen reached out to her mentor to

ask his opinion about applying for the role, he immediately encouraged her to apply, and he reached out to the Mayor to vouch for her. And now, she considers the Mayor as her key sponsor as well. She also reached out to the last person in the position and has a sorority sister who is a leader in the community. Both of them served as her coaches and advocates, who also helped guide her through the interview process with the Mayor.

Through the years, whenever Karen made a decision with her husband to relocate, she looked for three things in her new city: (1) a little Black church so she can have a spiritual center in her life; (2) a chapter of the NAACP, or another Black community group, keeping with the tradition of how she was raised; and (3) a chapter of her sorority, Delta Sigma Theta Sorority, Incorporated (of which she is a Diamond Life Member), because they are a public service organization and she knows she will automatically have someone who has her back to navigate the new community. She has been able to find all three in Appleton, Wisconsin.

Being the "Only One"

Karen feels one of the main challenges with being the only woman of color at her level in City Hall is that she cannot be everywhere and cannot be everything to everybody. She is constantly pulled in multiple directions with 11 Protected Classes she tries to advocate for equally, and it is exhausting. One of her goals to help counter this is to recognize and

nominate other people of color to join local boards and get involved in the community. She admits she has many well-intentioned, well-meaning, cool White people who want her to join their community boards, but she explains she is just one person being pulled in too many directions. Instead, she encourages them to look for young professionals of color and helps them fill some of those vacant seats. She was recently successful with one such placement. The Board is overjoyed with the person recommended, and the Black woman is thrilled with the opportunity. The real challenge now is finding enough people of color to go around.

What Would You Change?

When Karen ponders this question, she is immediately drawn back to the conversation she had with her son and daughter regarding her career path change and the "what if" scenarios. However, she admits each adversity she encountered and all the tears that followed have led her to what she sees as the pinnacle of her career. Each step in her journey prepared her for the next one. Therefore, she has no regrets and would not change anything.

Own Your Destiny: Karen's Advice

Karen's top-of-mind advice to younger women of color is to be comfortable in your own skin and do not be afraid to speak your truth. She warns to be mindful of the "Angry Black Woman" syndrome and do not fall victim to it at work

Dr. Tana M. Session
Copyright 2020
Working While Black: A Woman's Guide To Stop Being the Best Kept Secret

or home. She views this as a trap, and knows it will stop you from being heard and showing up as your authentic self. She wants the next generation to show up as their unique selves and be the best they can be regardless of their career choice. Pray and find your spiritual center daily, surround yourself with a support team and cherish them, and do not take your loved ones for granted. No one gets through this life alone. Karen is proud to be in a position where she is fully actualized and living at the pinnacle of Maslow's Hierarchy of Needs. She hopes her story and advice will help the next generation of young Black female professionals Stop Being the Best Kept Secret ® and unlock their unbridled success!

Dr. Tana M. Session
Copyright 2020
Working While Black: A Woman's Guide To Stop Being the Best Kept Secret

CONCLUSION

Based on the title of this book, you may be under the impression that it was written solely for the benefit of Black women. That's partially true. In fact, several Black women have thanked me for writing about "their" story in a true and authentic way that hasn't been done before. However, this book is for our Allies, too, in whatever form they may come: Black men, White men, White women, other people of color, our LBGTQ+ community and others. The purpose of sharing our stories and strategies we used ot succeed, in spite of these corporate systems not being designed for our success, is to finally pull back the curtain and allow others to walk in our shoes. The ultimate goal – and hope – is that this book will serve as a conversation starter in one-on-one meetings, in corporate Employee Resource/Affinity Groups, in the C-suite executive meetings and other circles where the Black voice is missing or the "only one."

The only way to truly address an issue and make sustainable change is to first have an honest conversation about it. Then you must agree on a level of accountability for decision-makers that will help increase the likelihood that real change will actually happen. And that can simply start with just one person...Y-O-U. Imagine you are a pebble thrown

into a small pond. Based on the size of that pond, you will be able to see the ripple effect of the pebble hitting the water and ultimately the water standing still again. In essence, you experienced the full effect of your impact – or effort. However, sometimes you may be a pebble thrown into the ocean. The waves will come and pull the pebble out to the deep waters, and you will never be able to see that body of water stand still. But just know that you made an impact. That initial ripple, before the waves came and pulled the pebble and sand away from the shore, made a difference. We can all be that pebble by using our power, privilege and influence of change to make our workplaces psychologically safe spaces where ALL employees feel included, that they belong and that they can ALL experience success with no barriers to entry. Use these empowering stories and strategies on how to **Own Your Power, Own Your Truth, Own Your Healing, Own Your Worth and Own Your Destiny** as your guide for your own success and helping others achieve theirs with no limitations – either real or perceived!

Dr. Tana M. Session
Copyright 2020
Working While Black: A Woman's Guide To Stop Being the Best Kept Secret

TERMS & DEFINITIONS

AED Associate Executive Director

CEO Chief Executive Officer

CFO Chief Financial Officer

COO Chief Operations Officer

ED Executive Director

HR Human Resources

SVP Senior Vice President

White Fragility:
Discomfort and defensiveness on the part of a White person when confronted by information about racial inequality and injustice. ~ Google.com

White Privilege:
inherent advantages possessed by a white person on the basis of their race in a society characterized by racial inequality and injustice. ~ Google.com

Dr. Tana M. Session
Copyright 2020
Working While Black: A Woman's Guide To Stop Being the Best Kept Secret

Thank You

I owe a debt of gratitude to Dr. Lois Frankel for giving me the courage to write my story and be bold and brave about it. Your book, *Nice Girls Don't Get the Corner Office*, was mentioned as a necessary career tool by a few of the women I interviewed, and I was honored to let them know you were the reason why I was on this journey. I hope this book will serve the same purpose for the next generation of female bosses! I look forward to sharing the stage with you one day soon!

Thank you to each of the phenomenal Black women who openly and honestly shared their stories, some for the very first time. I am truly honored that you let me into your space and shared your experiences to help guide, mentor and coach other Black women who may face similar issues in their personal and professional lives. You are each my SHEros!

Thank you to my husband, Dana "Dane," for always supporting me and helping me stay focused, and encouraging me to finish my biggest project to date, even on the days when I was ready to walk away from it. Thank you for being my biggest critic and biggest cheerleader. I love you more! We did it!!

Thank you to my son, Brandon, for just being you and continuing to be my North Star – the reason why I do everything I do is for you! You are my one true legacy! Mommy loves you, babe!

230

CPSIA information can be obtained
at www.ICGtesting.com
Printed in the USA
LVHW081931240921
698681LV00011B/119/J

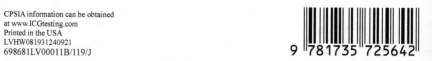

.